# THORPE HESLEY, SCHOLES & WENTWORTH

## THROUGH TIME

Mel & Joan Jones

AMBERLEY PUBLISHING

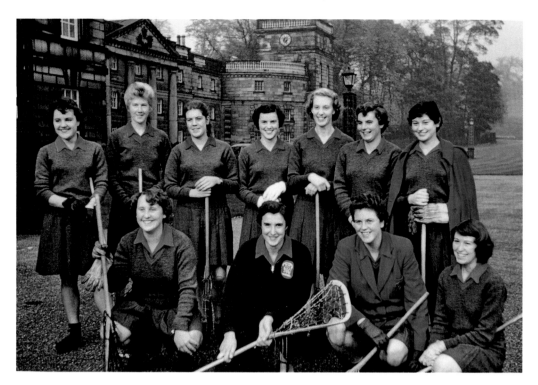

A lacrosse team outside Wentworth Woodhouse when it was the Lady Mabel College of Physical Education.

First published 2012

Amberley Publishing
The Hill, Stroud
Gloucestershire, GL5 4EP

www.amberley-books.com

Copyright © Mel & Joan Jones, 2012

The right of Mel & Joan Jones to be identified as the Authors of this work has been asserted in accordance with the Copyrights, Designs and Patents Act 1988.

ISBN 978 1 4456 0527 2

British Library Cataloguing in Publication Data.
A catalogue record for this book is available from the British Library.

Typeset in 9.5pt on 12pt Celeste.
Typesetting by Amberley Publishing.
Printed in the UK.

# Introduction

Beneath the village of Thorpe Hesley lie important ironstone and coal seams that were exploited from medieval times until relatively recently. The presence of coal and ironstone has meant that Thorpe was for centuries a place where farmers and smallholders were matched or out-numbered by miners and workers in the metal trades. Now both of these sources of employment have disappeared and the old straggling working village has been engulfed by extensive modern residential development. The village has two historical claims to fame, one spiritual, one criminal. It was an early centre of Methodism and attracted visits from the Wesleys. It also got a reputation in the early nineteenth century as a place where certain members of the population were addicted to sheep stealing and it got the nickname 'Mutton Town'.

Wentworth village is neat and simply laid out and has the character of a village set deep in rural England rather than a highly urbanised region. The first features of interest to be encountered when entering the village from the west are the almshouses and the former school at Barrow that date from the early eighteenth century. But these are a mere prelude to the village proper which starts with the ruined, largely medieval church and its surrounding graveyard and then stretches eastwards, largely confined to one street, Main Street, with farmsteads, cottages, public houses and shops, almost all in local stone. At the end of the village is the former Home Farm and this together with the exclusive use of one colour of paint – Wentworth green – reveal that Wentworth was until quite recently an estate village.

The main entrance to Wentworth Park is down the drive from the Octagon Lodge. The park visitor first passes the large and impressive stable block designed by the eighteenth-century architect, John Carr of York. It is so extensive that some first-time visitors have mistaken it for the mansion. But the mansion is much grander and its eastern-facing front, 606 feet long in the Palladian style, is longer than that

of any other country house in England. This was the residence of the earls Fitzwilliam and their predecessors the Marquises of Rockingham. Surrounding the mansion extends a great park adorned with a serpentine lake and a herd of red deer.

The smallest settlement, Scholes, is different again. Like Wentworth, Scholes is a street village, but this time it twists and turns sinuously. It has long been a village of farms and cottages, the chapel and school are both closed and it contains no church. It was once the home of miners and nailmakers but in the last thirty years has become largely a dormitory village.

The selected photographs, old and new, provide a comprehensive pictorial record of more than a century of economic, social, and physical change. They celebrate people and places and the changing environment and should be of lasting interest to long-established residents and relative newcomers alike.

Sheep may (now) safely graze.

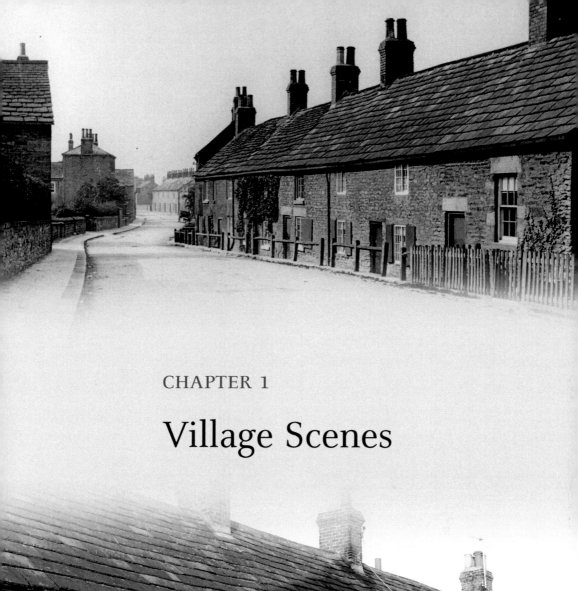

# CHAPTER 1

# Village Scenes

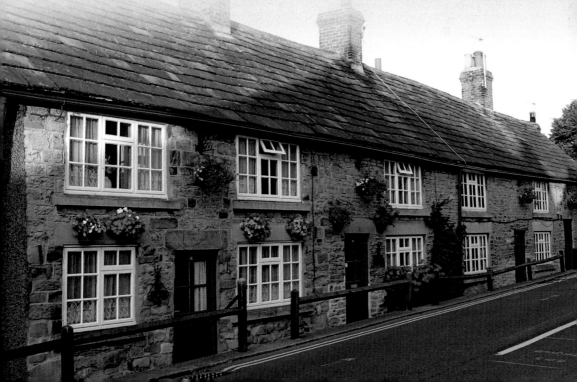

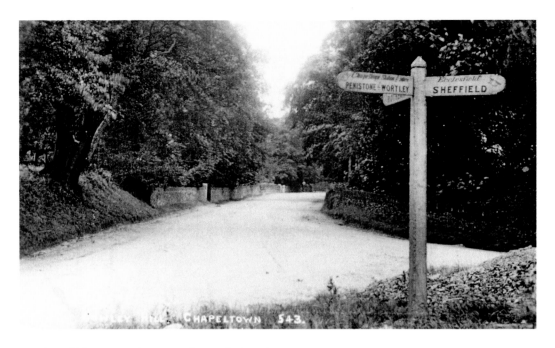

## Cowley Hill between Thorpe Hesley and Chapeltown

The early photograph shows a quiet country lane. Over 100 years later, as the modern photograph shows, all has changed. There are road markings, traffic lights and even a cycle lane. Cowley Hill took on a completely new role in 1968 with the opening of the M1 motorway. Junction 35 is just a quarter of a mile up the hill and the road is now busy day and night with goods vehicles and commuters' cars.

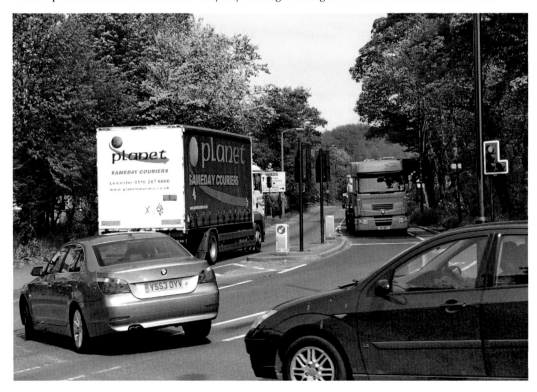

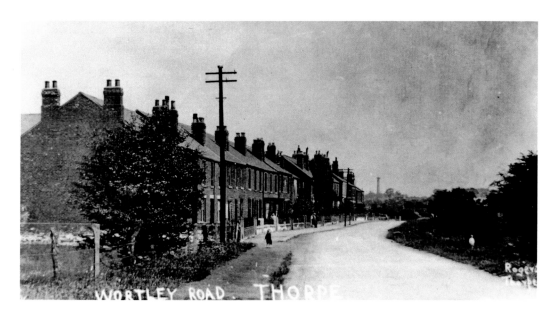

**Upper Wortley Road, Thorpe Hesley**

Upper Wortley Road (A629), which links Rotherham to Wortley and then to Huddersfield, is an ancient routeway. It was part of an ancient 60-mile-long route linking Rotherham to the saltfields of Cheshire. It became a turnpike road in 1788. It was along this road that the sheep were driven from Rotherham market to Manchester and tempted some 'Thorpers' into sheep stealing. Today it links Rotherham with the M1 motorway at junction 35.

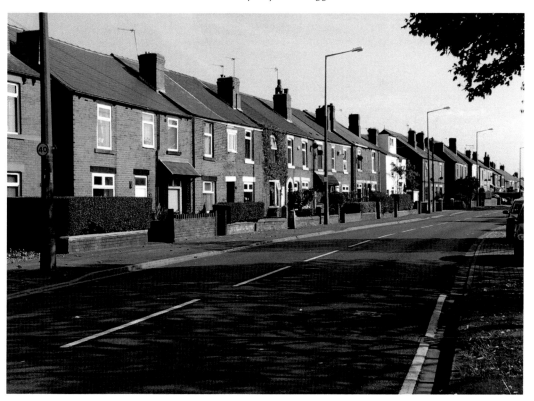

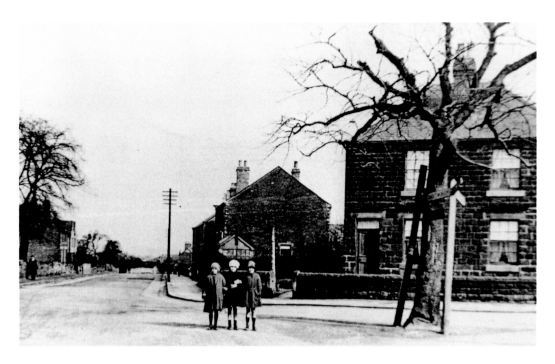

Hesley Bar, Thorpe Hesley

Hesley Bar was formerly part of Upper Wortley Road. It is called Hesley Bar because of the former existence of a toll bar on the turnpike road from Rotherham. The ash tree shown in the early photograph had a grisly legend attached to it. Where ash trees grew at crossroads or road junctions, it was generally believed locally that this tree marked the burial of a suicide who could not be buried in consecrated ground.

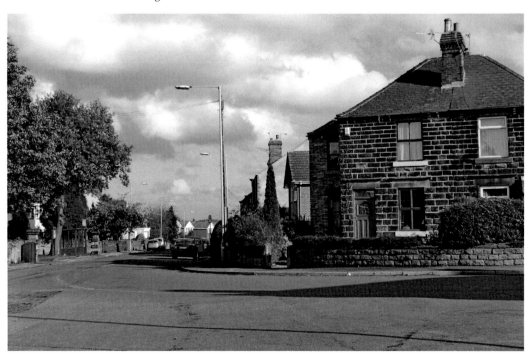

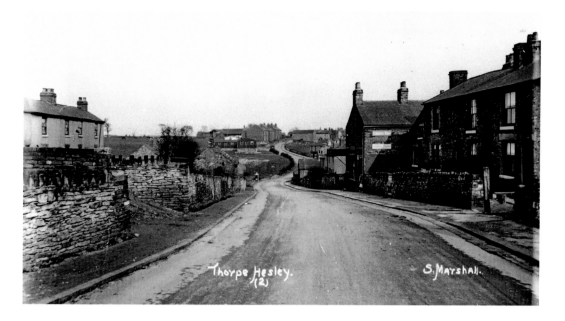

## Hesley Lane, Thorpe Hesley

The early photograph emphasises the almost invariable use of stone not only for the traditional buildings in the village but also for wall boundaries at the sides of roads. The rows of terraced houses that once stretched along the left-hand side of the lane have now disappeared and have been replaced by more modern housing in brick.

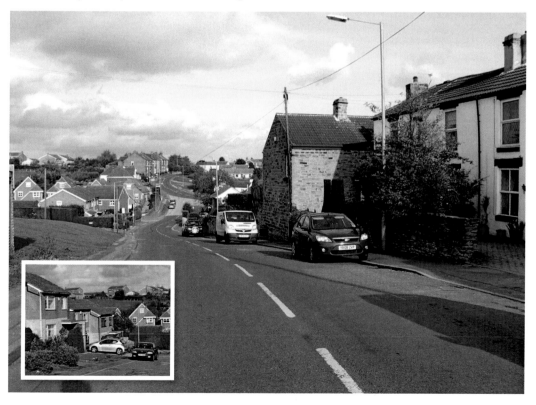

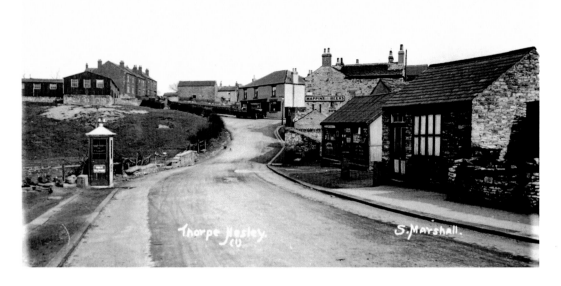

### The Bottom End of Hesley Lane, Thorpe Hesley

These two views are looking down Hesley Lane towards the Red Lion. In the early photograph immediately on the right was a cobbler's shop. It is said that from the 1920s until the early 1940s the cobbler was a keen Anglican who refused to repair the boots and shoes of Methodists! Beyond the cobbler's shop was a chemist's shop belonging to the Marshall family. In the background, the building with a lorry parked in front of it was the Foresters' Arms.

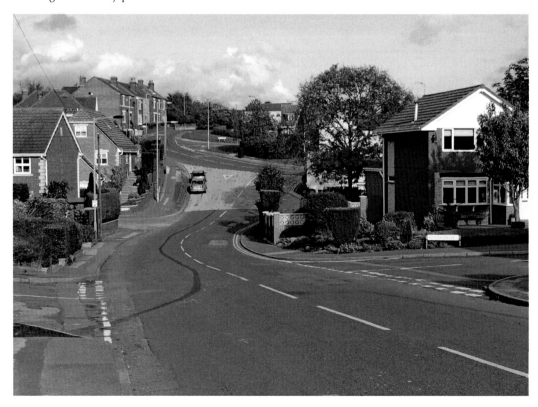

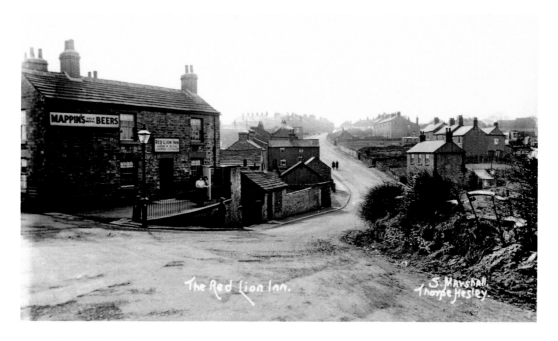

## The Red Lion, Thorpe Hesley

These views look south-westerly up Hesley Lane with the Red Lion public house on the left. The early photograph, like the early photographs on the previous two pages, is from a postcard sold by Marshall's, who had a chemist's shop at the bottom of Hesley Lane. The inset shows the floriferous hanging baskets in the summer of 2011.

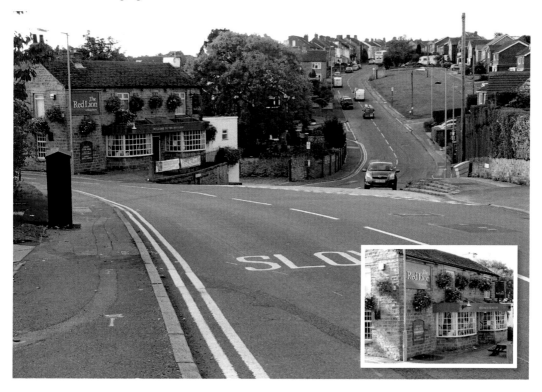

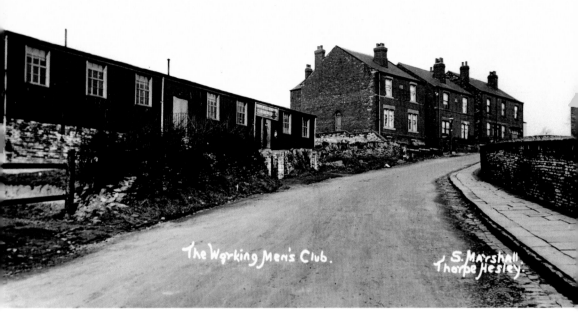

## The Site of Thorpe Hesley Working Men's Club

The early photograph shows the short-lived Thorpe Hesley Working Men's Club. It was built in 1921 but never thrived after the General Strike of 1926. On 27 April 1932, the building was auctioned and bought for £260. The site is now largely occupied by residential bungalows.

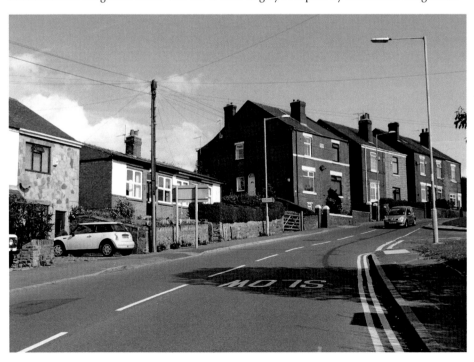

The Near Houses

S.Marshall
Thorpe Hesley.

**Barnsley Road, Thorpe Hesley**
The early photograph shows Barnsley Road looking north-westwards. On the left is the housing estate for colliery officials at Barley Hall Colliery. The estate had been built by Newton Chambers Ltd of Thorncliffe Ironworks that owned and ran the colliery. When the coal industry was nationalised in 1947, the housing estate became the property of the National Coal Board. The modern photographs show close-ups of some of the houses on the estate and the stone cottages on the opposite side of the road.

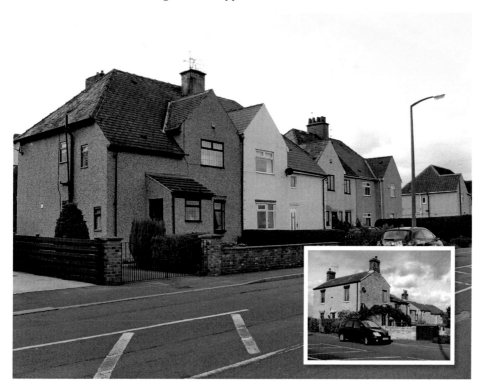

13

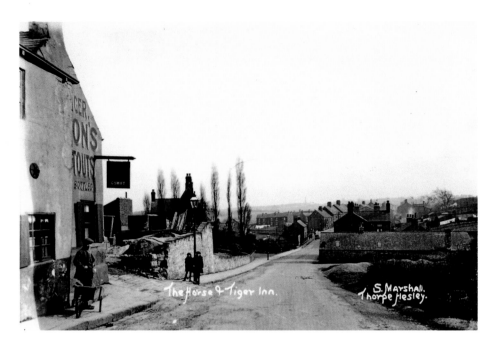

## Horse & Tiger, Thorpe Hesley

The Horse & Tiger public house was a new build in the 1930s to replace a nineteenth-century building. It has the notable distinction of being the only pub in the entire country with that name. In 1920 the then landlord, Charles Moxon, was fined £5 for 'filling drink after time'. And the man caught drinking it was also fined £5 – a good week's wages in those days. The long building on the right-hand side of the road was the village blacksmith's shop.

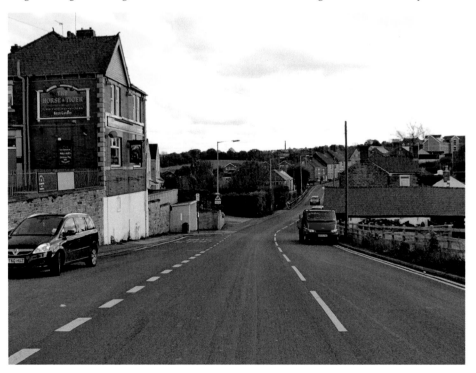

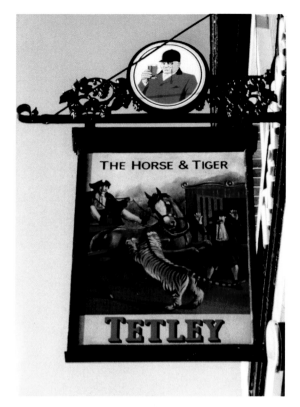

## Horse & Tiger, Pub Sign

Above is an old pub sign and below is the present pub sign. The story goes that the pub name commemorates an incident that took place in the village during the Victorian period. It is said that a tiger escaped from a travelling circus and attacked a horse. The incident is most faithfully depicted on the old sign. Travelling menageries or wild beast shows were regular attractions in towns and villages throughout the country in the past. One of the most famous of these was Wombwell's Wild Beast Show, which even did a command performance for Queen Victoria and her family. It was a regular visitor to the towns of South Yorkshire and it put on a show at Chapeltown just one mile from Thorpe Hesley in the week ending 1 November 1878. The log book of High Green School records that the school was closed early so that the children could attend the wild beast show. Why the more recent pub sign shows a knight in armour and a tiger attacking a man, not a horse, is a mystery.

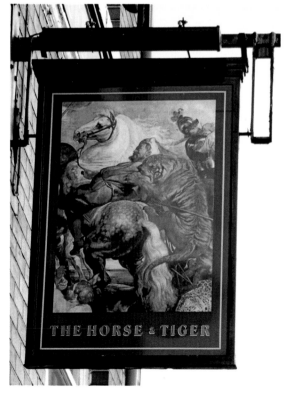

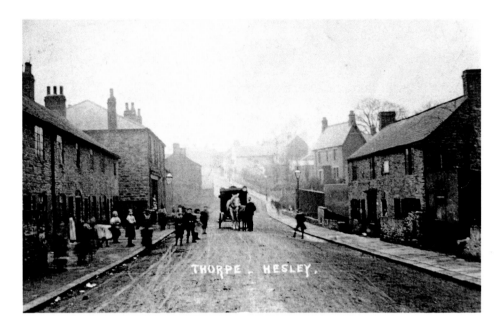

### Brook Hill, Thorpe Hesley

The two photographs show the view looking north-westwards along Brook Hill up towards the Red Lion public house. Halfway along the left-hand side of the street is the village shop. In the 1890s it was in the ownership of George and Catherine Spreckley. In 1919, Arthur Pilley took over the shop and he was succeeded by his son. The Pilleys are said to have sold everything 'from a candle to three-piece suite'. The store is still a going concern.

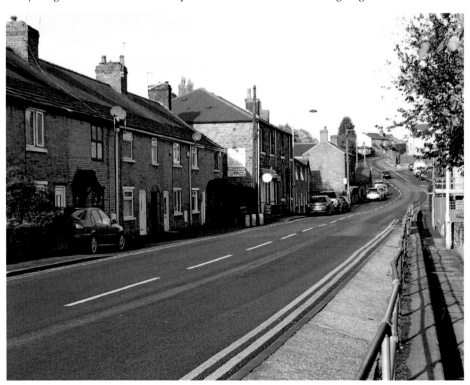

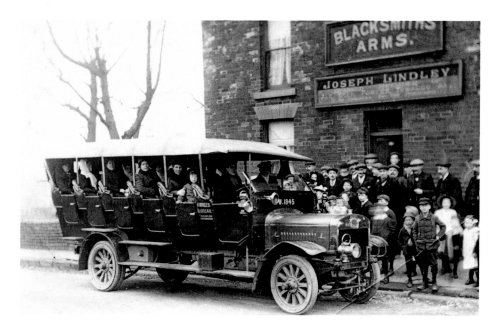

### The Blacksmith's Arms

The early photograph shows a charabanc outing outside the Blacksmith's Arms halfway up Brook Hill. The charabanc made a big difference to outings in its heyday in the 1920s and 1930s. There was no need to walk to and from a railway station and trips could go to destinations far from railway stations such as Sherwood Forest or parts of the Peak District. The pub has now gone, replaced by a block of apartments called Blacksmith Court as shown below.

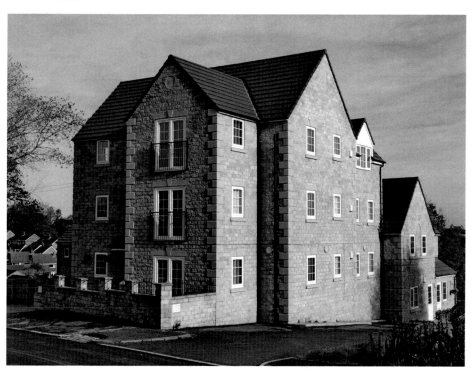

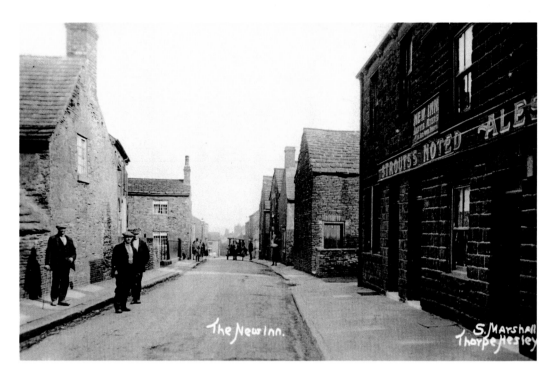

## The New Inn, Thorpe Street, Thorpe Hesley

The old photograph shows the top of Thorpe Street in the 1920s with the New Inn in the right foreground. It has long been closed. Then as now a feature of this part of the village are the house gables at right angles to the street, giving rise to its once local name of 'the street of gable ends'.

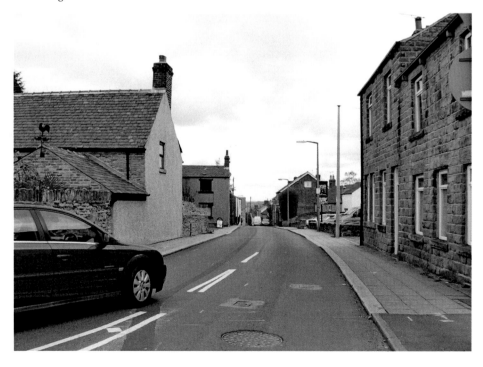

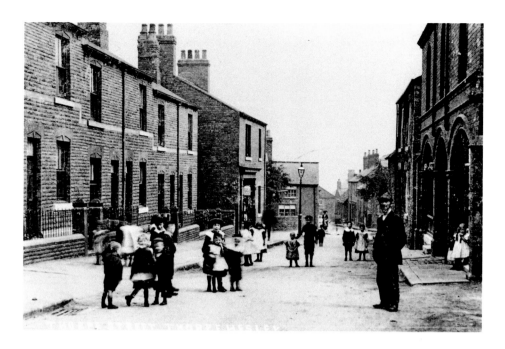

## Thorpe Street, Thorpe Hesley

Two contrasting scenes on Thorpe Street, Thorpe Hesley, are shown. Gone from the modern, busy street are the crowds of children standing and playing quite safely in the middle of the thoroughfare, the only traffic likely to disturb their games being a slow-moving horse and cart. Gone too are the commercial premises that are shown in the early photograph except for the Chinese takeaway in the lower part of the red brick building on the right.

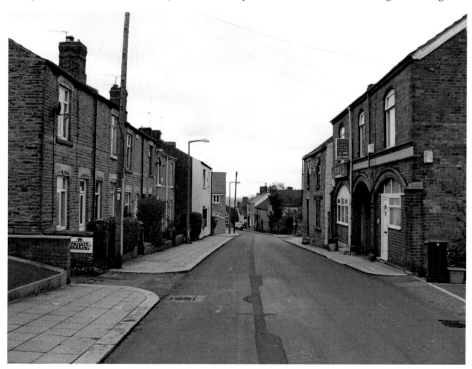

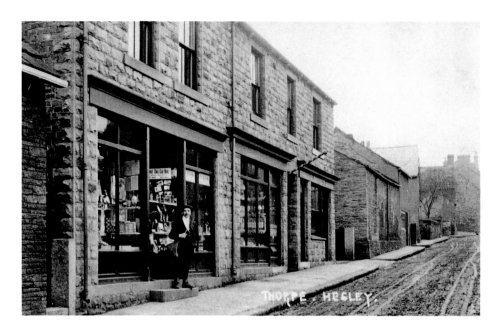

**Shops on Thorpe Street, Thorpe Hesley**

The street has not been asphalted on the early photograph and the tyre marks of carts can be clearly seen. Although the shop windows remain nearest the camera, all the shops are now closed. The furthest shop on the early photograph says 'C. Bennett, family grocer'; it later became Coldwell's. There is then a barber's pole and then a sweet shop. The shop nearest the camera was Taylor's draper's and post office by 1922, and later became William Heeley's newsagent's shop.

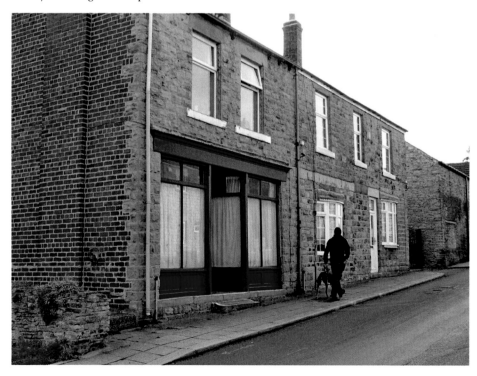

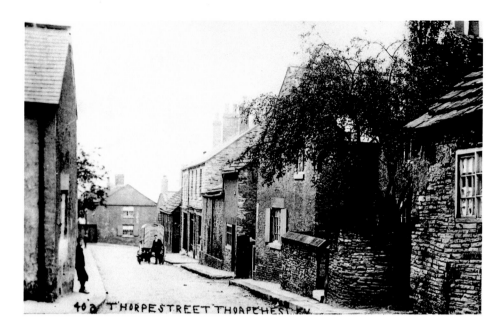

'Slatethorpe'

Both photographs show Thorpe Street, Thorpe Hesley, looking east. The early photograph shows clearly that both the walls and roofs of the old cottages are of a thin, slaty sandstone, giving rise to the village nickname 'Slatethorpe'. Also visible on the early photograph are the wooden window shutters, once almost universal, now a rarity. On the left-hand side of the street the old farmhouse and other farm buildings have been demolished, and a small housing estate now occupies the site.

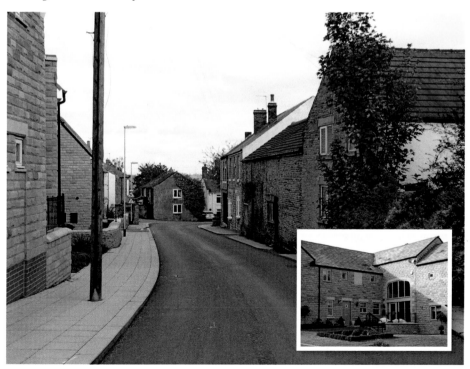

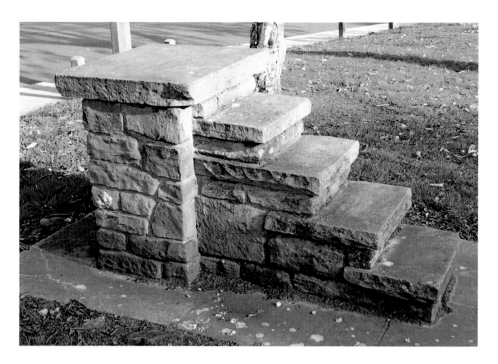

## John and Charles Wesley

The steps shown above commemorate the location from which John Wesley preached at 'the Marble Arch' at the bottom of Thorpe Street in Thorpe Hesley. John and his brother Charles Wesley visited Thorpe Hesley more than a dozen times between 1742 and 1786. On 4 July 1786 John Wesley said he 'preached at Thorpe to three or four times as many as the preaching house would have contained'. His name is now commemorated in a street name in the village.

The 'Bird Estate', Thorpe Hesley

Built in the late 1970s and early 1980s, this extensive residential adjunct of brick and tile in contrast to the stone-built village core is distinctive in quite another way. Every street name contains the name of a bird. In contrast to the ancient village street names such as Brook Hill, Hesley Lane and Thorpe Street, on the bird estate these are replaced by names such as Fulmer Way, Goldcrest Walk and Lapwing Vale.

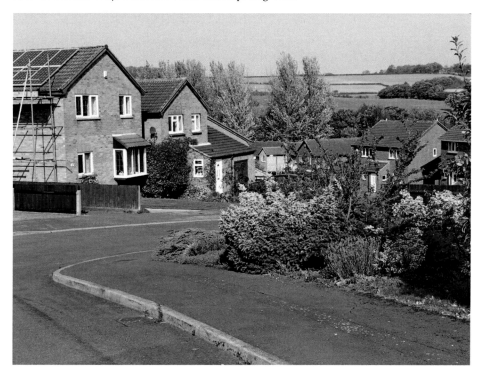

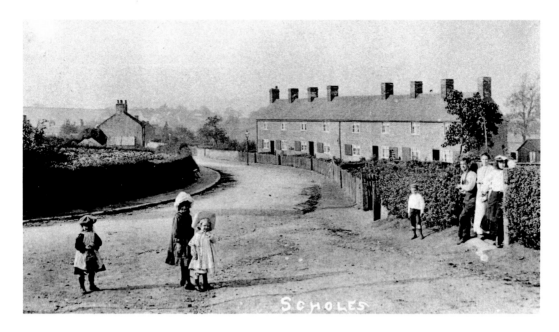

## The Southern End of Scholes Village

The old photograph above shows this part of the village in the early 1900s. The inset shows a smart turnout in Scholes village in 1906. There are far fewer children in Scholes today and the calls of children playing are a rarity. A hundred years ago the village was the home of numerous mining families with young children. In 1891, out of an adult male population of 102, no fewer than 88 were coal miners. Today it is a dormitory village.

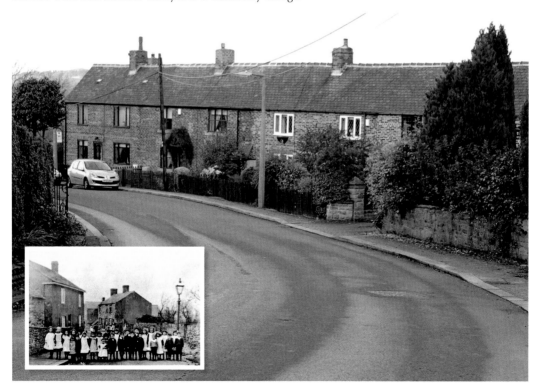

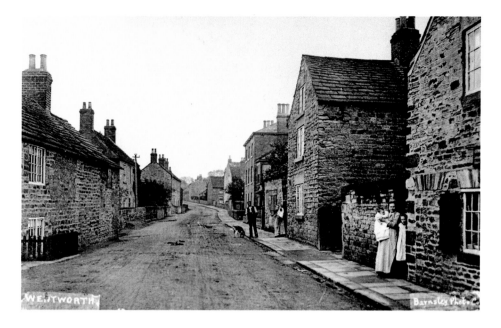

## Main Street, Wentworth

The early photograph shows Main Street before it was asphalted in 1914. Wentworth is probably the best example in South Yorkshire of a street village, where, with the exception of a small number of buildings on Clayfields Lane, the whole village, including farms, church and shops, are all congregated on or near the main village street. And now as in the past almost every door is painted in a dark green, 'Wentworth green', reflecting the fact that Wentworth is an estate village with almost every building belonging to one owner.

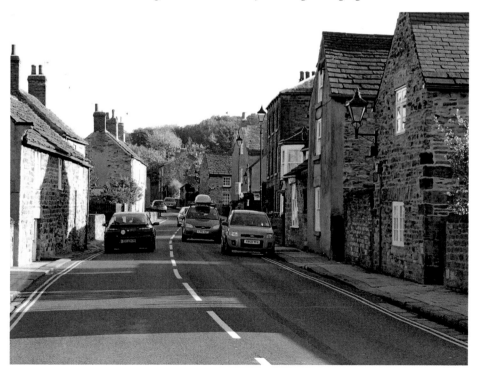

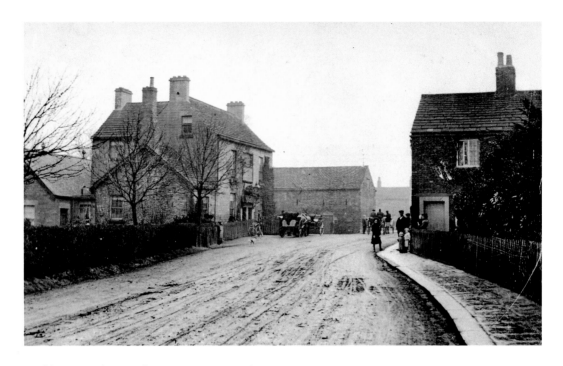

## Looking East along Main Street, Wentworth

On the left is the Rockingham Arms, one of the two public houses in the village. There was once a third one, a beerhouse at the junction of Main Street with Clayfields Lane. On the right is the old toll house, built in brick rather than the usual stone.

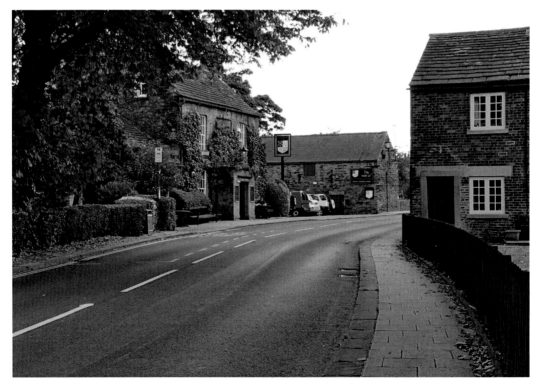

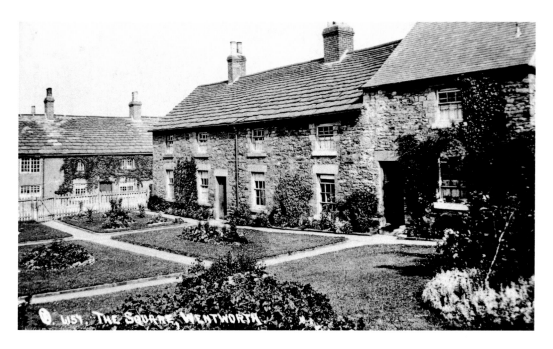

## Paradise Square, Wentworth

This is a most attractive group of cottages in the village situated round a central beautifully tended garden area. In fact, Paradise Square was not built as a residential area. It was a farm where the farmhouse, barns and other outhouses were converted to residential use. The former farm fold yard (farmyard) now forms the central area of gardens. The old photograph looks onto Main Street and the modern view is from Main Street.

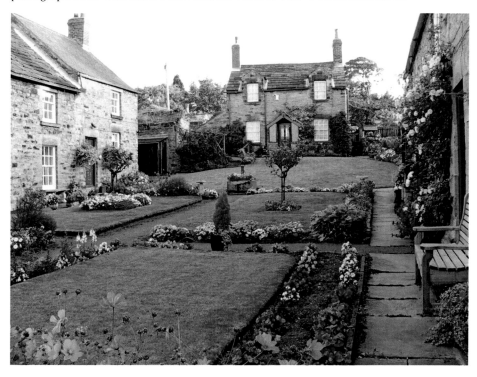

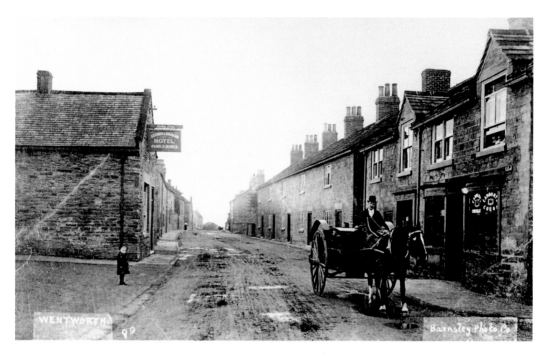

**George & Dragon Yard and Village Stores, Main Street, Wentworth**
On the old photograph the small child is standing at the bottom of the yard leading to the George & Dragon public house. At the time the photograph was taken the landlord was John Smith Rimes. He was the landlord at the time of the 1891 census and he was still landlord in 1922, in his mid-seventies. On the right-hand side of the road is the village store which first opened at the beginning of the nineteenth century and is still going strong today.

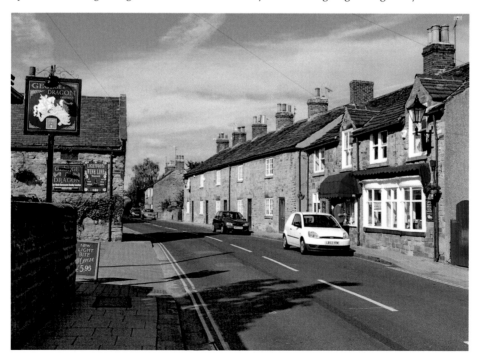

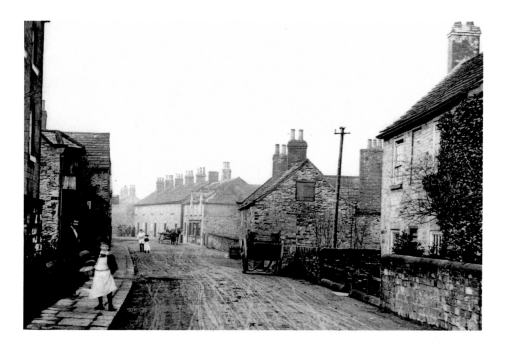

## Another View of Main Street, Wentworth

The photographs show Main Street looking west towards the village store. At the time that the early photograph was taken, everyone living in the village was either a tenant or a direct employee of Earl Fitzwilliam. And son followed father into the earl's employment. One old resident recalled that on the day (Friday) that he left the village school he was called into the head teacher's office to be told that he should report for work in the gardens on the Monday morning.

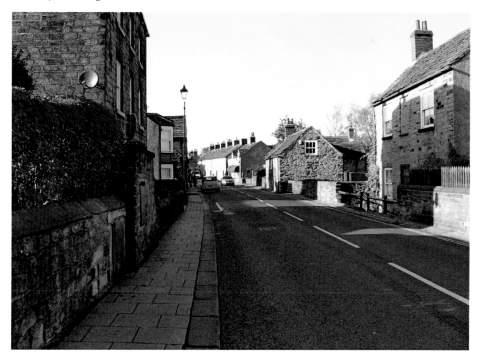

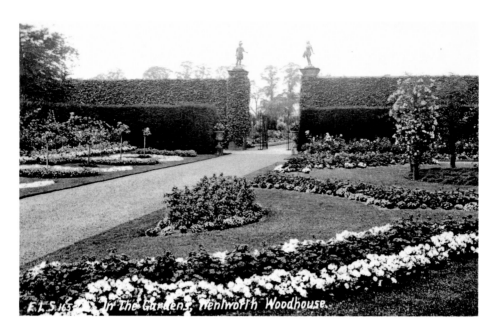

## Carpet Bedding, Wentworth Gardens

The early photograph shows the eastern entrance to the kitchen garden at Wentworth Woodhouse with the statues of Lucretia and Collatinus. The central pathway is flanked by carpet bedding plants. The pathway ran from the mansion, through the gardens to a door on Hague Lane. From Hague Lane another wide pathway led to the parish church. Below are potted cyclamen plants on display in the garden centre that now occupies the site of the kitchen garden.

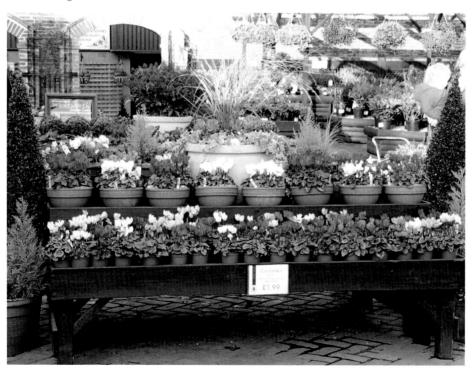

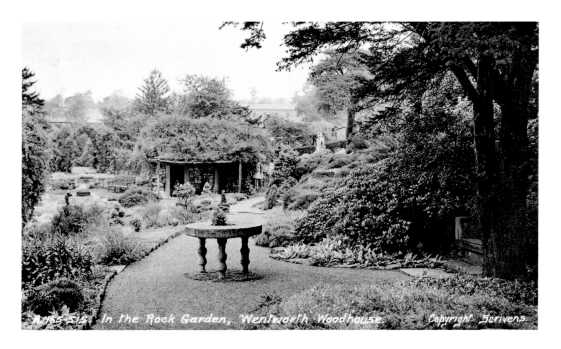

A765-515. In the Rock Garden, Wentworth Woodhouse. — Copyright Scrivens.

The Japanese Garden, Wentworth

The garden was created in an existing rock garden by Countess Maud in the early years of the twentieth century. There was a much publicised Japanese-British Exhibition at the White City in 1910 with two Japanese gardens. Following the exhibition a number of well-known gardens were created in the Japanese style. Perhaps Countess Maud visited the exhibition. The garden still contains Japanese stone lanterns and, as can be seen in the modern photograph, a particularly beautiful Japanese maple.

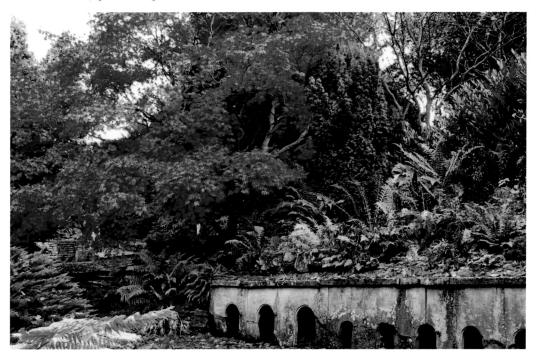

31

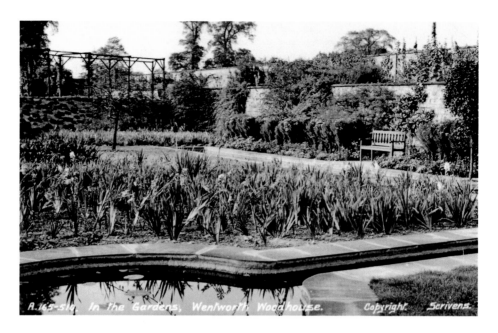

The Italianate Garden, Wentworth

Another part of the former Wentworth Woodhouse gardens, and like the Japanese garden, now part of the garden centre and accessible to the public, is the Italianate garden. Water features form an important part of this garden. There is a small pond and two straight-edged canals. There are some interesting trees in this garden including a Japanese larch and two weeping copper beeches, under one of which is a stone statue of a very large dog.

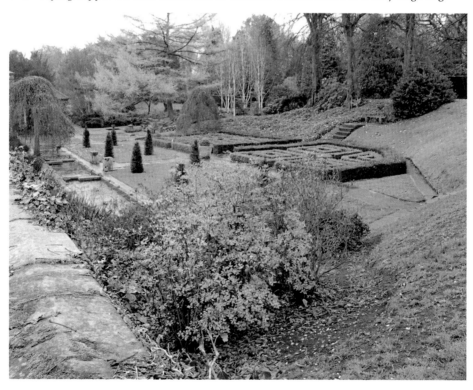

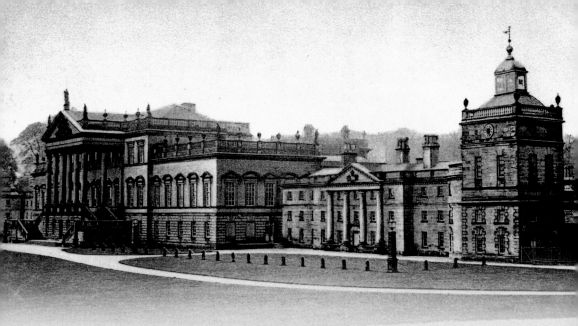

# CHAPTER 2

# Landmarks

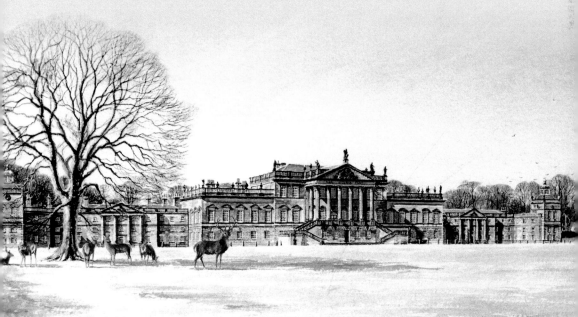

WENTWORTH WOODHOUSE

Allan Womersley
'95

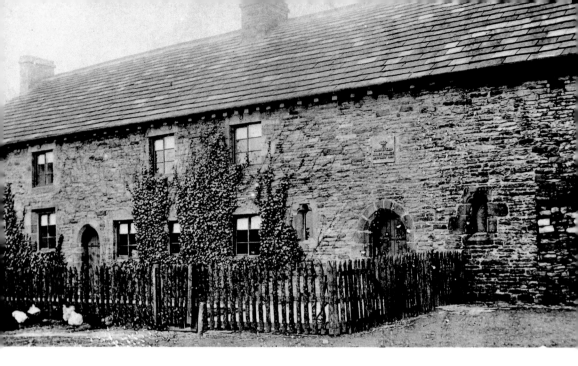

## Kirkstead Abbey Grange

This is the much altered descendant of the headquarters building of a grange built following a grant by the Norman lord, Richard de Builli, to the monks of Kirkstead Abbey in Lincolnshire in 1161. The grant allowed the monks to mine ironstone and make iron. They were given permission to build two furnaces, two forges, to collect dead wood from the common for fuel, to pasture their horses and oxen on the common and to build their headquarters and lay out a garden.

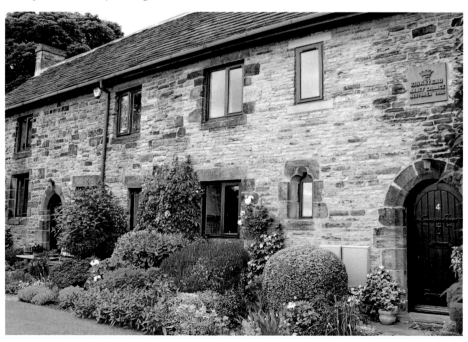

### Cowshed and Hayloft at Kirkstead Abbey Grange

Following the Dissolution of the Monasteries in the sixteenth century the grange became a farmhouse. It was in use for several hundred years for tenant farmers, some of whom had the dual occupation of farmer and nailmaker. Attached to the farmhouse in the style of a longhouse were barns, stables and cowsheds. Then about 1860 the elderly tenant farmer left because the house 'did not contribute to comfort according to modern notions' and it remained empty for forty years until 1900 when it was fully restored. It then became a farmhouse again with tenant farmers until 1934 when it was bought by the sitting tenant. It remained a farmhouse until 1983. In 1984–85 the house and barns were converted into private homes. Shown here is the cowshed and hayloft shortly before the 1984 restoration and in 2011. In an inventory compiled in 1694 the cowshed contained a pair of oxen, two kine (cows) and three calves.

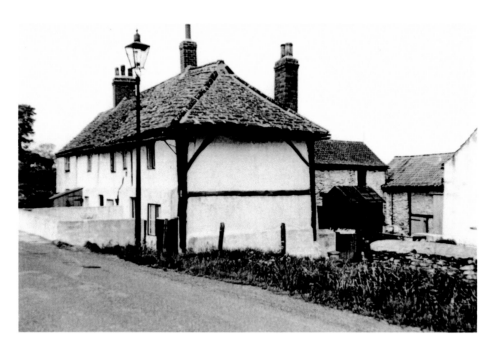

Nether Fold

Nether Fold was for centuries a yeoman farmer's house and is one of the very few timber-framed buildings surviving in the local area. Parts of beams and sections of the roof structure taken from the building during restorations in 1981 have undergone dendrochronological (tree ring) analysis and this showed that the trees from which they were shaped had been felled in 1494 or early 1495.

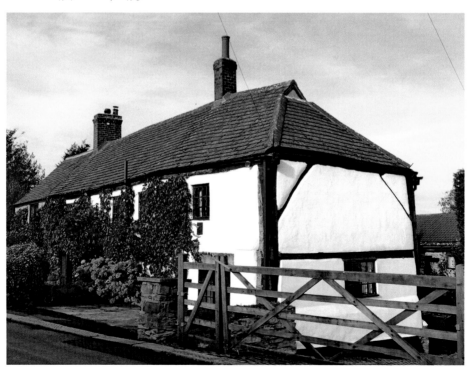

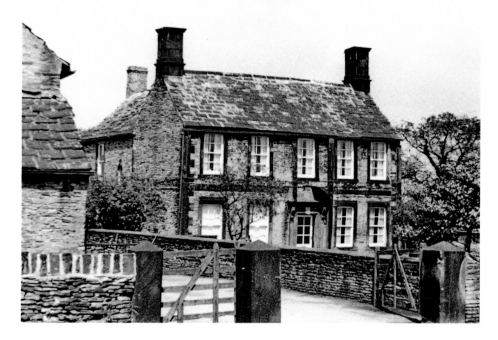

## Hesley Hall

This attractive stone-built, eighteenth-century farmhouse stands near the top of Hesley Lane in Thorpe Hesley. It was still surrounded by a moat as recently as 1900. An earlier house on the site was referred to in a survey of 1637 as 'Heslow Hall, moated around'. The occupant at that time was Humfrey Northall, who combined his farming activities with the position of keeper of the red deer in Cowley Woods (the present Smithy Wood) for the Earl of Shrewsbury.

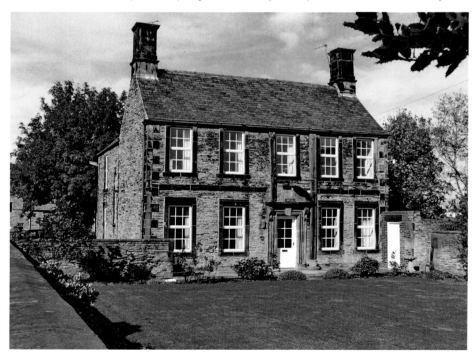

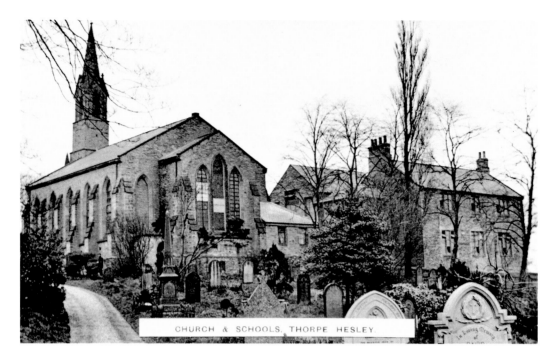

CHURCH & SCHOOLS, THORPE HESLEY.

## Holy Trinity Church and National School, Thorpe Hesley

The first stone for the church was laid in March 1837 on part of two crofts donated by Earl Fitzwilliam. The money for the building of the church was raised by voluntary subscription with the Countess of Effingham of Thundercliffe Grange championing the appeal. The church was first opened for public worship on 17 July 1839. In August 1838 Hannah Rawson gave land for the building of the National School and master's house beside the church. The school closed in 1929.

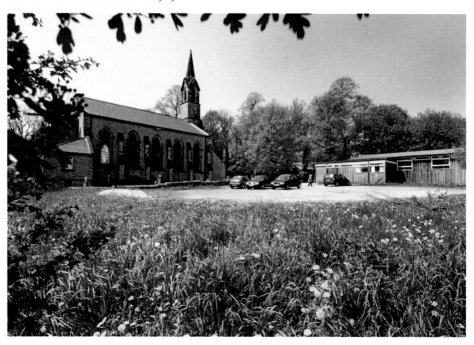

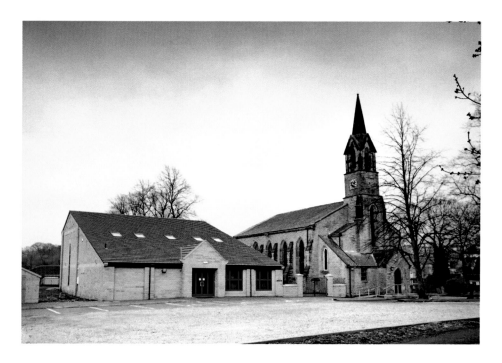

## The New Community Centre

In the modern photograph on the previous page, beside the church is the old community centre which was replaced by the Trinity Community Centre, officially opened in 2008 (see the accompanying celebrations on the book cover). The building of the new centre was funded by the Big Lottery, WREN, Rotherham MBC, Sheffield Diocese, the Methodist Church and community fundraising. The photograph below shows Thorpe Hesley Brass Band rehearsing at the Centre.

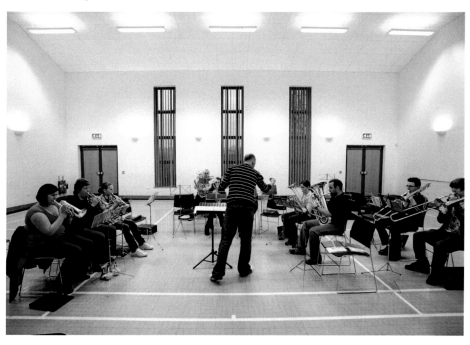

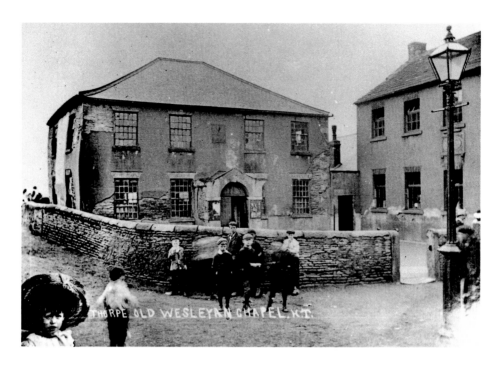

## The Thorpe Street Chapels

The old chapel (above) was built in 1797 in the neo-classical style under the supervision of Samuel Birks who, as a young man, had rescued Charles Wesley from an angry mob by driving his plough horses into them. Beside it stood the Sunday School. On 6 May 1906, the programme for the Sunday School Anniversary announced that 'this will be the last sermon in the old chapel'. The new Wesleyan Methodist chapel (below) was opened in 1907. It is now closed.

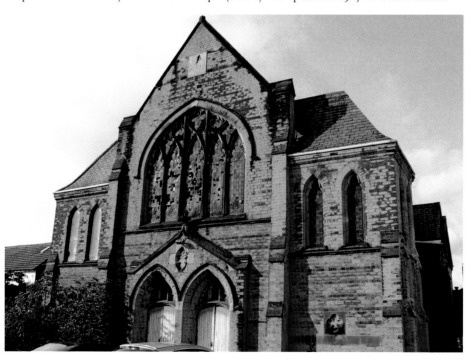

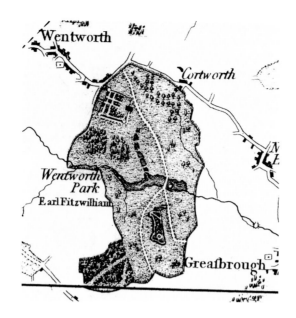

## Iron Age Camp in Scholes Coppice

Scholes Coppice was a coppice wood until 1727 when it was 'cut into walks for beauty' and incorporated into Wentworth Park. The wood with its walks is shown on Burdett's map of 1791 above. One of these walks is still a major trackway through the wood and it passes very close to an Iron Age camp. This well-preserved fort was once known as Castle Holmes and Caesar's Camp. The earthwork consists of a single bank and ditch enclosing a flat area of about one acre in extent. The bank, 50 feet wide in places, still stands several feet above the interior and rises more than 15 feet above the bottom of the ditch which is also about 50 feet wide. The counterscarp beyond the ditch rises in places to 7 feet. Excavations have suggested that when occupied the bank was surmounted by a timber palisade.

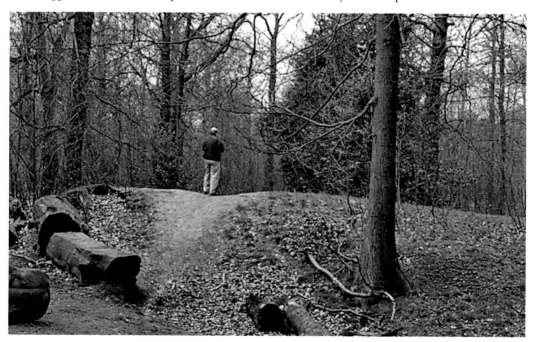

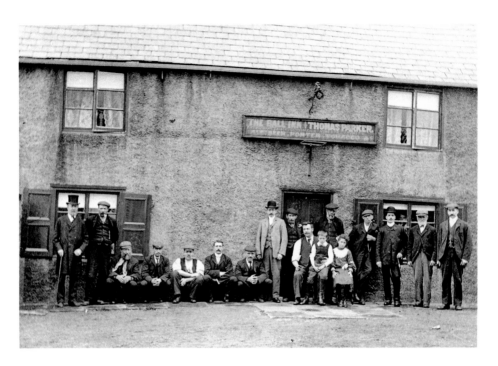

## The Old Ball Inn

These two photographs show the old Ball Inn in the early 1900s when Thomas Parker was landlord. He is sitting in the middle of the group in the top photograph with his children and standing in the middle of the group in the bottom photograph. The fact that Thorpe Hesley was a mining village at that time is reflected by the fact that five of the regulars in the top photograph are adopting the 'miners' squat' for the photographer.

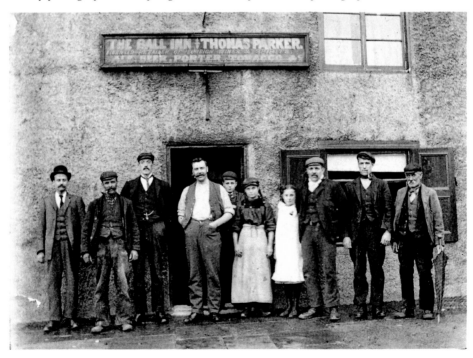

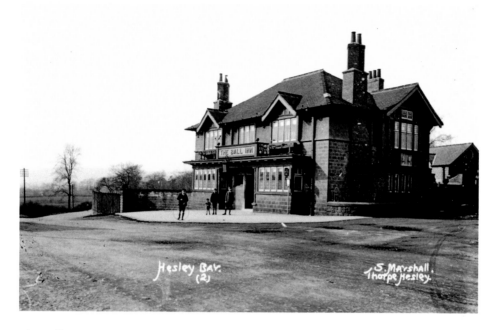

## The Ball Inn

This new building in the mock Tudor style had replaced the old Ball Inn before the First World War. At that time it was on a busy road which was diverted with the building of the M1 motorway in 1968, but the pub now stands in a quiet corner of the village. The name may be derived from the old name for an early iron smelting site (bole, bail or ball). These relied on natural blasts of air from prevailing winds.

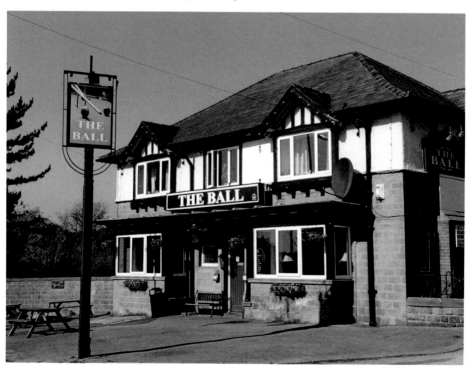

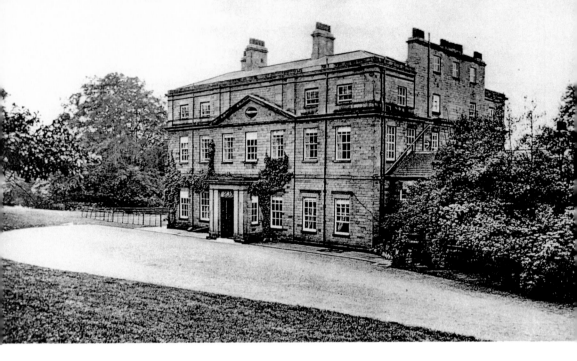

## Thundercliffe Grange

Thundercliffe Grange was built between 1776 and 1783 by John Platt the South Yorkshire mason-cum-architect. It was the new home of the 3rd Earl of Effingham whose old home, Holmes Hall near Rotherham, was becoming increasingly uninhabitable because of the industrial expansion of the town. Successive earls of Effingham resided at Thundercliffe until 1860, when again industrialisation and the coming of the South Yorkshire Railway forced another move. The family then moved to an estate in Oxfordshire.

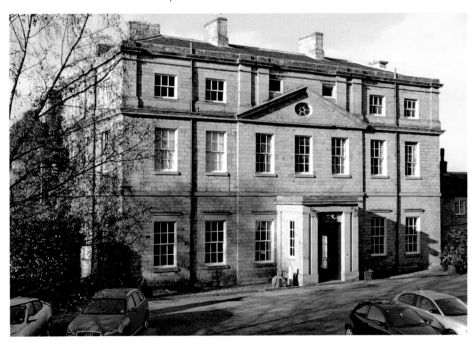

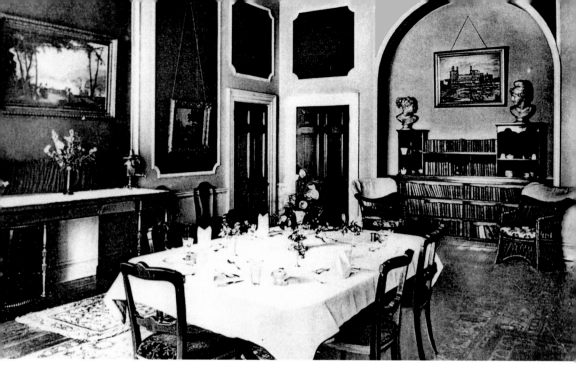

### The Old Dining Room at Thundercliffe Grange

Thundercliffe Grange, from at least the 1890s until the early 1980s, was successively a sanatorium for the 'care and cure of mental invalids (ladies)' and a children's hospital. The photograph above shows the dining room as it was featured in a prospectus in the early 1900s. The Grange is now split into private apartments. The dining room is now used for musical and dramatic performances, for local history talks and every Christmas local carols are sung there by candlelight.

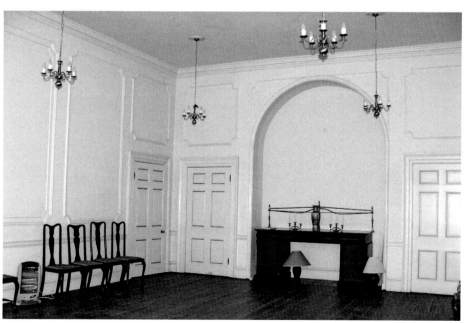

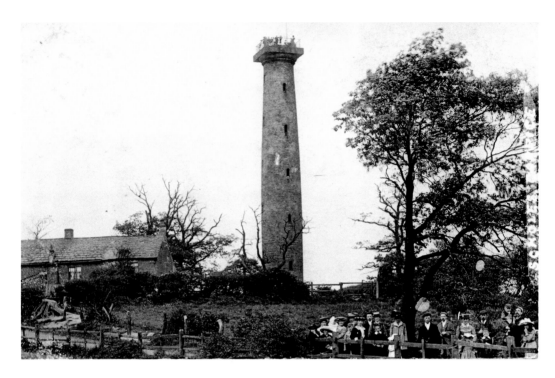

### Keppel's Column

This 115-foot-high monument lies at the former southernmost tip of the Wentworth estate. It was begun in 1773 and completed in 1780. The second Marquis of Rockingham decided in 1779 that it should be a monument to his political ally Admiral Keppel, who had been court-martialled for not engaging the French fleet in 1778 (he was acquitted). It has long been a destination for local walkers, cyclists and picnickers as the large group of Edwardian ladies and gentlemen below shows.

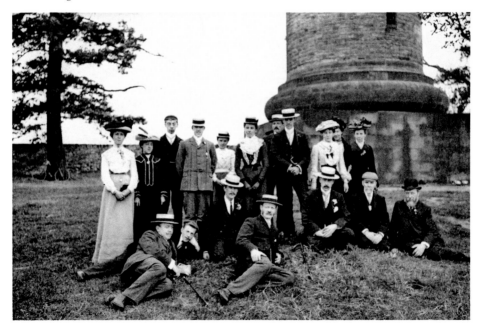

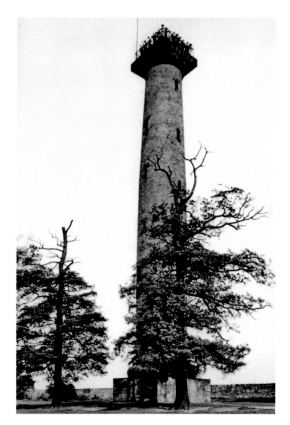

## Visiting Keppel's Column

For many decades the monument was
open to the public on payment of a
penny. This involved climbing 217
steep steps that wound up to the top
of the column. A crowd of people can
be seen leaning over the guard rail at
the top of the photograph above. Local
doctors used to prescribe a visit to the
top of the column followed by deep
breathing exercises for patients with
chest complaints! Apparently halfway up
the steep climb of the spiralling stairway
there is a small room with a stone table.
Whether this is where patients who
did not quite make it to the top were
laid out is a matter of dispute locally!
The monument has been closed to the
public for the last 50 years. In Keppel's
Field, which runs down the slope from
the Column towards Scholes Coppice,
there is an area of wet ground containing
marsh orchids.

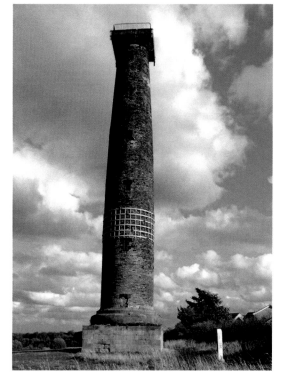

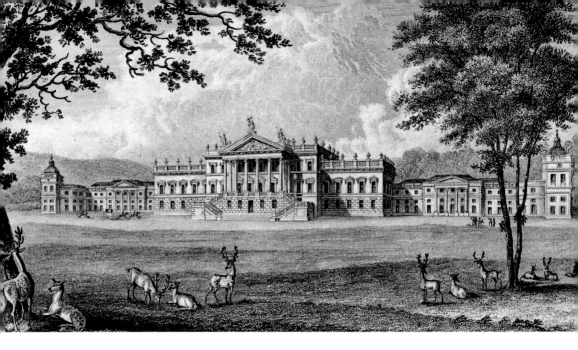

## Wentworth Park

The deer park at Wentworth is one of only two remaining deer parks in South Yorkshire with a herd of deer, in this case about 100 red deer. The visitor is very likely to see the deer grazing among the trees which are scattered about the park. Parkland once stretched away to the east and south much more than it does today. By the end of the eighteenth century, the park extended from north to south for more than 3.5 kilometres.

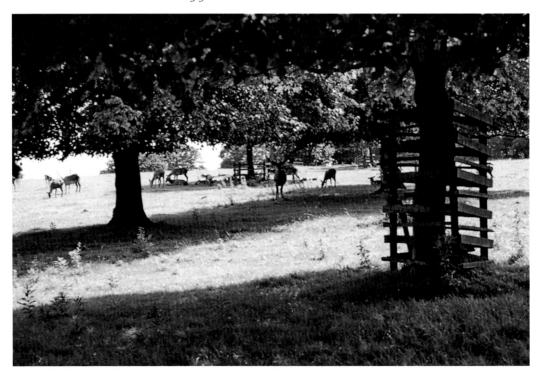

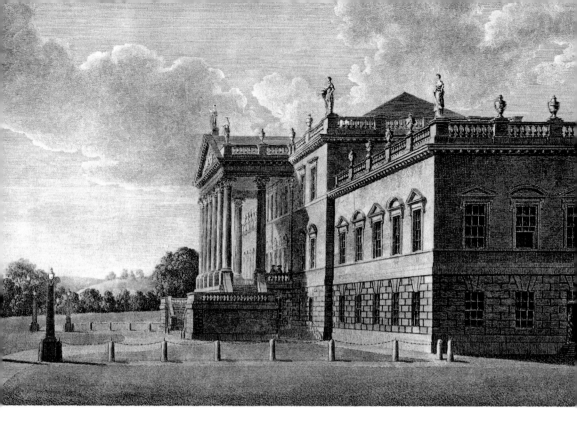

## Wentworth Woodhouse: Two Houses Back-to-Back

The mansion that can be seen from the park and shown above is the East or Palladian Front, designed by the 1st Marquis of Rockingham's architect, Henry Flitcroft. Between 1724 and 1732 the Marquis had built another house in the more florid Baroque style, facing west (shown below). In 1732 he began work on the east facing mansion, the west facing house being thought to be unfashionable. The East Front is about 606 feet (183 metres) long, the longest country house front in England.

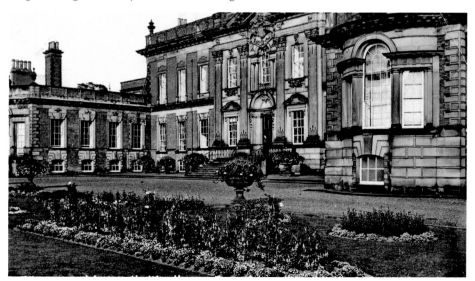

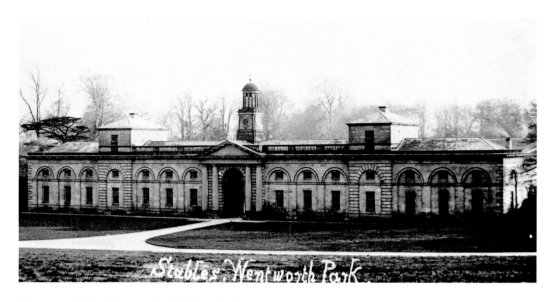

Stables, Wentworth Park

**Wentworth Woodhouse, the Stable Block**

This building is so stylish and grand that it is sometimes mistaken by first-time visitors for the mansion! It was designed by John Carr of York and built between 1768 and 1789. It originally housed riding and carriage horses, as well as carriages and coaches, and later motor cars. Staff also lived in the stable block until the end of the 1940s. In the latter days of its existence as a college site the stable block was converted into office and teaching accommodation.

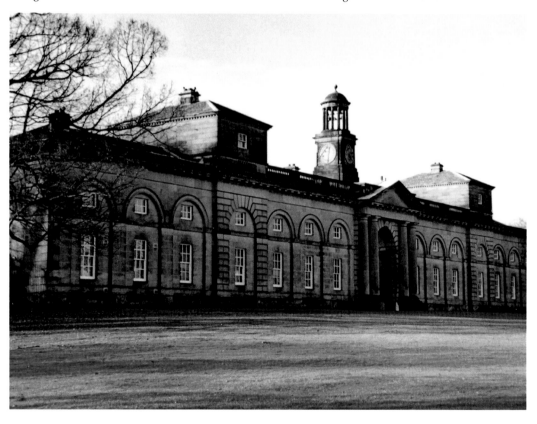

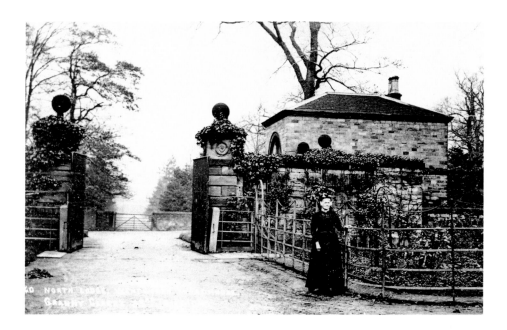

## The North Lodge

The photograph above shows Granny Clark beside the North Lodge, one of six surviving lodges built in the second half of the eighteenth century and the early nineteenth century at various park entrances and once occupied by gatekeepers. The photograph was taken on her 83rd birthday in 1905. The modern photograph shows Donatia Shelmerdine, her great-great-granddaughter standing outside the North Lodge in January 2012. Donatia was named after Donatia Fitzwilliam, one of the daughters of the 7th Earl Fitzwilliam.

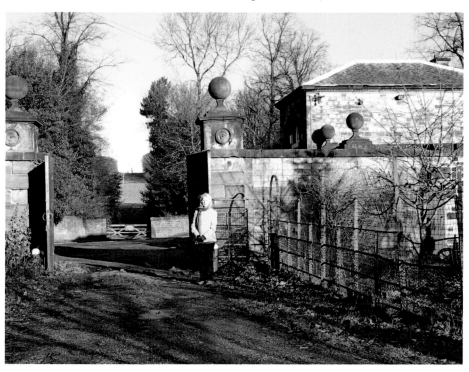

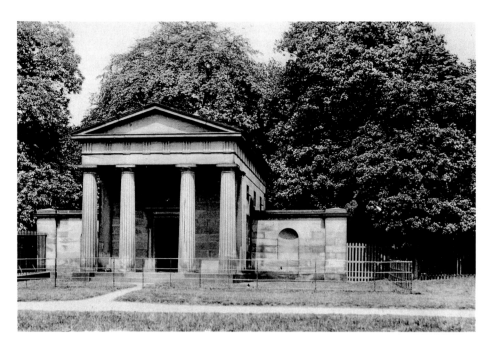

### The Doric Lodge

This lodge in pale yellow sandstone, now a three-bedroom family home, is the most architecturally striking of the six lodges that surround the park. Its portico is supported by four columns in the Doric style. Originally the lodge stood beside the gates of a coach road that led from the mansion to the Sheffield to Barnsley road (the A6135). Across the road from the lodge the stone wall is broken by iron railings showing the route of the coach road.

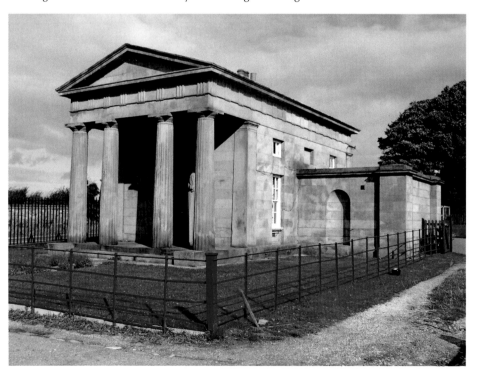

## Mausoleum Lodge

Away from other settlements along Cortworth Lane towards Nether Haugh, the Mausoleum Lodge has for more than two centuries housed, among their other estate responsibilities, the custodians of the Mausoleum which stands in an isolated position on high ground within the park. Apart from keeping away unwanted visitors, the park keeper now supervises the visits of those interested in the history of the Wentworth area. The mausoleum is open to the public on Sunday afternoons between June and September each year.

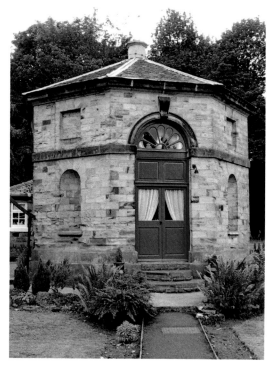

589 Mausoleum Lodge, Wentworth.

53

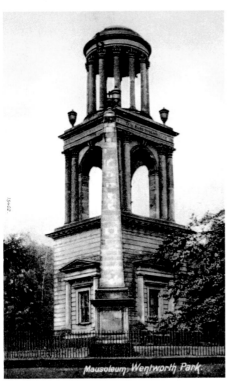

Mausoleum, Wentworth Park.

## The Mausoleum

This imposing memorial is to the 2nd Marquis of Rockingham, a leading Whig politician of his age. Rockingham was a strong opponent of Lord North and his government's policy which led Britain into the War of Independence with the American colonies. North's electoral defeat in 1782 brought Rockingham to prime ministerial office for the second time but he died in office during his first year of power. The monument is not a mausoleum in the real sense because the Marquis' body was buried in York Minster. It was built on behalf of the Marquis' nephew, the 4th Earl Fitzwilliam, who inherited the Wentworth estate in 1782. It was designed by John Carr and completed over a four year period from 1784 to 1788. Outside stand the obelisks that once decorated the ornamental gardens in front of the Baroque west-facing mansion.

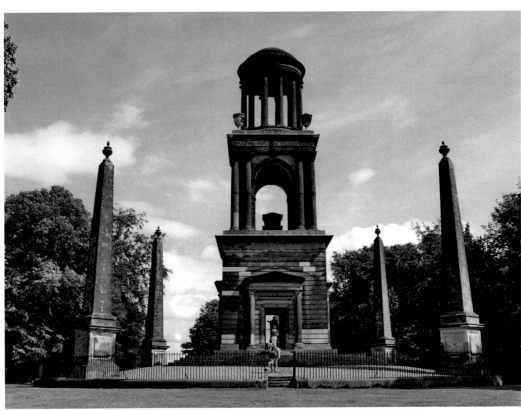

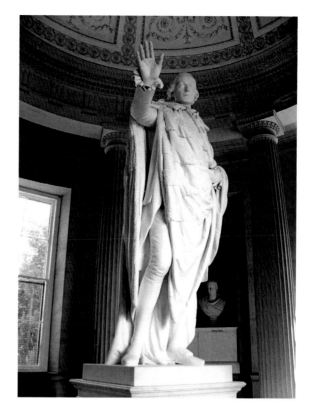

## Inside the Mausoleum

The ground floor is an enclosed hall containing a life-size marble statue of the Marquis robed as a Roman senator. Around the walls are niches containing busts of eight of his close political allies: Charles James Fox, Edmund Burke, Lord John Cavendish, John Lee, the Duke of Portland, Frederick Montague, Sir George Saville and, as shown here, Admiral Augustus Keppel.

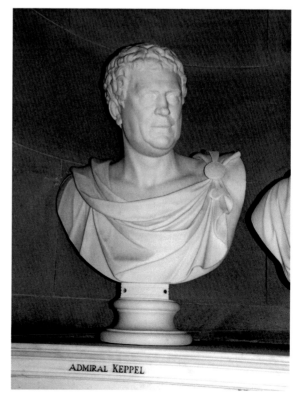

ADMIRAL KEPPEL

55

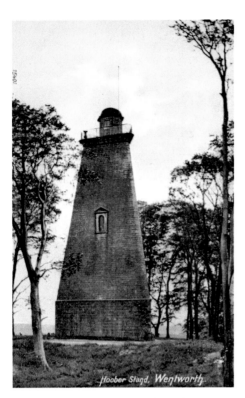

Hoober Stand, Wentworth

## Hoober Stand

Another political monument, Hoober Stand, can be seen from the eastern end of the park on one of the highest points in the surrounding countryside. It is open to the public on Sunday afternoons from the beginning of June until the end of September, and from the top are glorious views of South Yorkshire. It was begun in 1747 in honour of King George II and the suppression of the 1745 Jacobite rebellion. The 1st Marquis' son, Charles, the future 2nd Marquis, had run away during the rebellion and joined the King's army under the Duke of Cumberland. No doubt the monument also enshrined the Marquis' relief at the safe return of his only surviving son and heir.

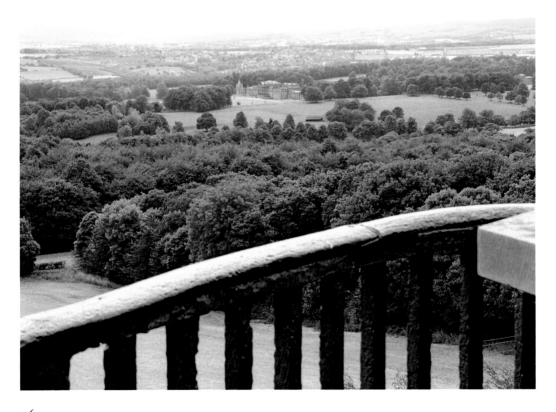

## Needle's Eye

Standing on the edge of Lee Wood, this small pyramidal monument is surrounded by a myth. This surrounds the fact that the monument is pierced by a gothic archway. It is said that it was built by the 2nd Marquis of Rockingham after he bet a member of his London club in 1780 that he could drive a horse and carriage through the eye of a needle. In fact the monument was recorded as early as 1732. Did he make the bet because he knew for certain he could win it because the Needle's Eye monument was already there? Scratched into the stone are the initials of some of the visitors to the monument over the centuries.

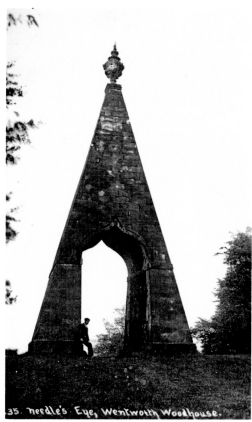

35. needle's Eye, Wentworth Woodhouse.

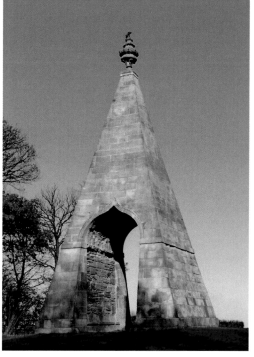

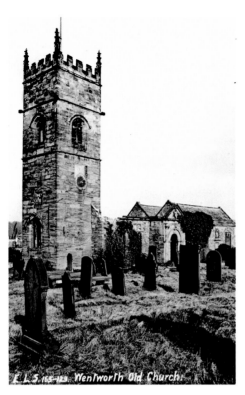

Wentworth Old Church

## Wentworth Old Church

The remains of Wentworth old church, comprising the west tower, the chancel and the north chapel, are all medieval. The church contains capitals and other materials brought from the dissolved Monk Bretton Priory. The old church was a chapel-of-ease for the township of Wentworth in the large parish of Wath, the parish church being four miles away. The square-headed windows have heraldry above and close examination of the tower reveals masons' marks. The upper parts of the tower fell down in the high winds of the great gale of 1962. The church is now in the care of the Churches Conservation Trust.

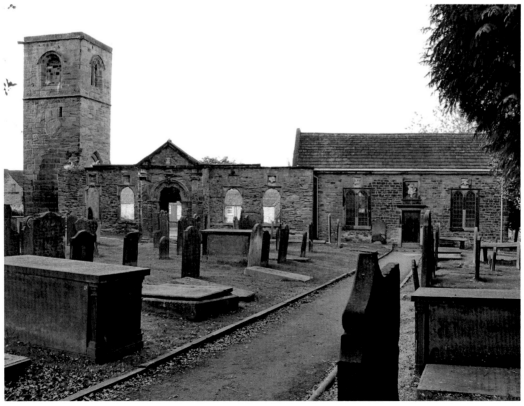

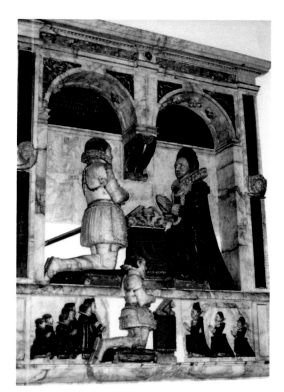

## Monuments in Wentworth Old Church

The old church contains six memorials to the Wentworth family. The one shown opposite is a hanging wall monument to Sir William Wentworth (died 1614) and his wife Anna (died 1611), the two adults kneeling at a prayer desk. Sir William is wearing his best suit of armour. Below the parents in the part of the monument called the predella are their eleven children, boys on the left and girls on the right. The eldest son, Thomas Wentworth, the future 1st Earl of Strafford is shown much bigger than the other children. From 1633 to 1639 the Earl was Lord Deputy of Ireland and was beheaded on Tower Hill in 1641. He was known by the Irish as 'Black Tom', who saw him as a despotic colonial overlord. In the former estate village of Tinehely in County Wicklow there is a public house called Black Tom's Tavern and one of the inn signs shows an executioner with an axe in one hand and Black Tom's head in the other! The monument below is of Thomas Wentworth (died 1587) and his wife Margaret in the form of two alabaster figures on a tomb-chest. They are wearing their best ruffs and their heads are resting on braided tasselled pillows.

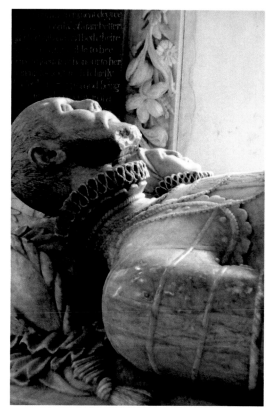

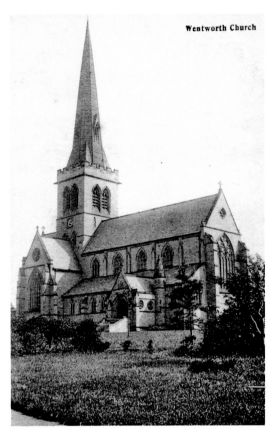

Wentworth Parish Church
The last service in the old church took
place on Sunday evening, 29 July 1877.
The new church, Holy Trinity, was
consecrated on Tuesday 31 July 1877
by the Archbishop of York. It is in
the Gothic Revival style by one of the
leading Victorian exponents of the style,
John Loughborough Pearson. Its spire
rises to 200 feet and can be seen for
miles around. It was designed to seat a
congregation of 540. Sir Nicholas Pevsner,
the eminent architectural historian, said
'the Fitzwilliams of the day could not
have spent their money more judiciously'.
Each Spring Bank Holiday the church
becomes a venue for an art exhibition by
local artists.

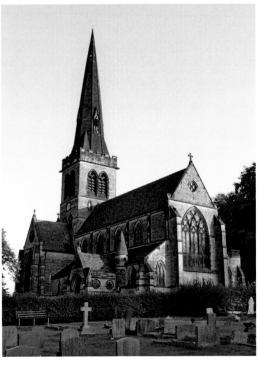

**Interior of Wentworth Parish Church**

Both photographs show the view looking east towards the altar which is backed by a reredos carved in stone depicting the last supper. The roof is rib-vaulted and the nave is separated from the aisles by pillars carved as clusters of tree trunks. The great east window, showing scenes from the life of Christ, is by Clayton and Bell and was completed in 1888 in memory of Admiral the Hon. George Henry Douglas, agent to the 6th Earl Fitzwilliam.

Interior, Wentworth Church.

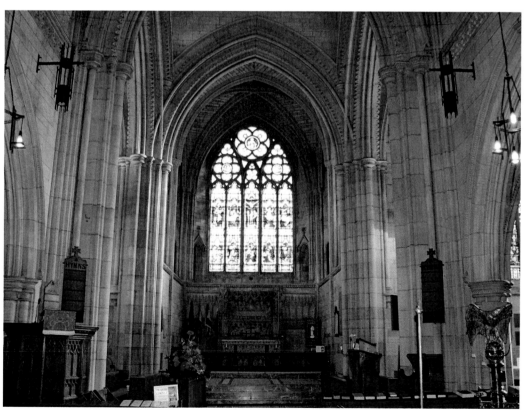

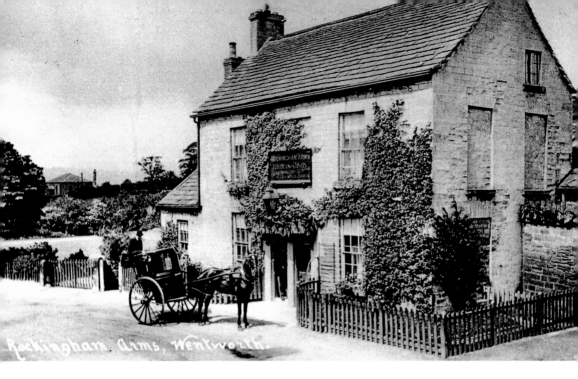

## Rockingham Arms

The name relates to the title adopted by Thomas Watson Wentworth when he became 1st Marquis of that name in 1746. His grandmother, who was the sister of the 2nd Earl of Strafford, was Lady Rockingham of Rockingham Castle in Northamptonshire. The same name was given to the family's pottery at Swinton and to their colliery at Birdwell. The main building probably dates from the eighteenth century. Note the change in the mode of transport used in coming for a drink!

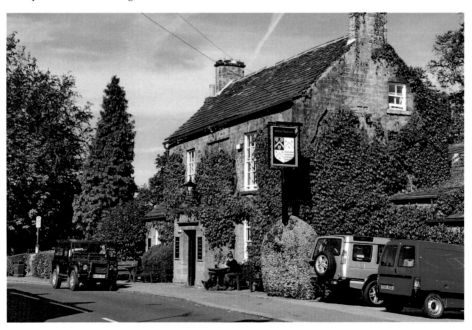

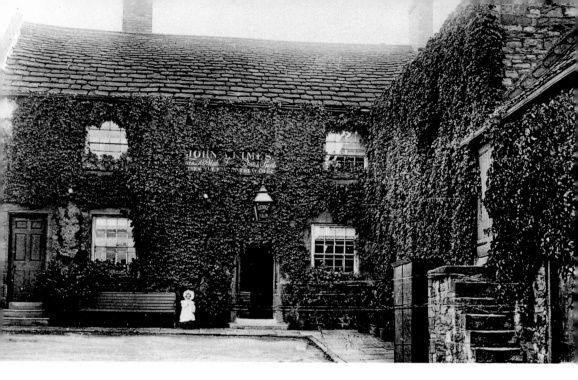

## George & Dragon

The building is probably of seventeenth-century date when it was not a public house but a private dwelling, but it has been a public house since the eighteenth century. The space in front of the George & Dragon was used in the past as a village marketplace. Both the George & Dragon and the Rockingham Arms were officially (!) not open for business on Sundays until the 1970s, originally on the orders of the 5th Earl Fitzwilliam (1783–1858).

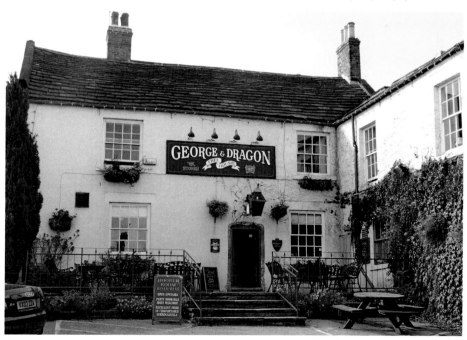

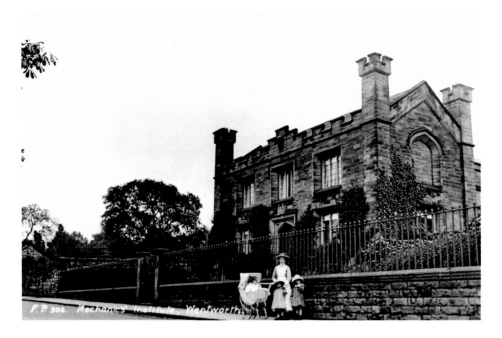

## Mechanics' Institute

The Mechanics' Institute was built in the early 1820s on the orders of Viscount Milton, who succeeded as the 5th Earl Fitzwilliam in 1833. It was among the first of such institutions to be formed in the country. It originally had a library and it was designed as a meeting place and educational venue for working men as an alternative to the public house. The library has now gone but it still performs a broad educational role as the village hall.

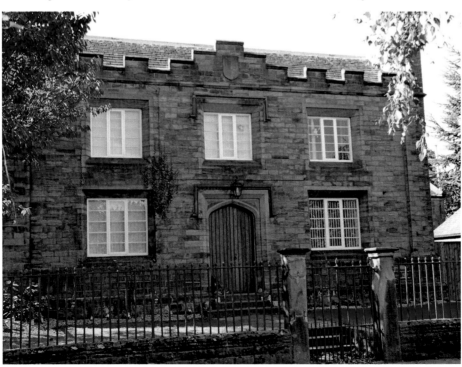

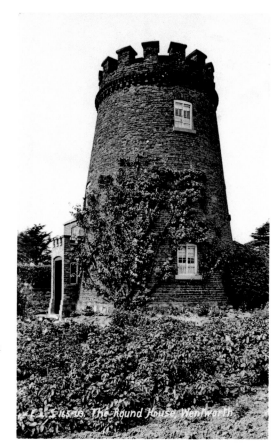

**The Roundhouse in Clayfields Lane**
This is one of three windmills once known to have stood in the Wentworth area. It was probably the 'new wind miln' built in 1745 by the Marquis of Rockingham. In July of that year payment was made for 158,000 bricks and the Roundhouse is made from handmade bricks. By 1793 it was no longer a working windmill and it was converted into a cottage called the Saxon Tower. This is probably when the castellated top to the old windmill was added.

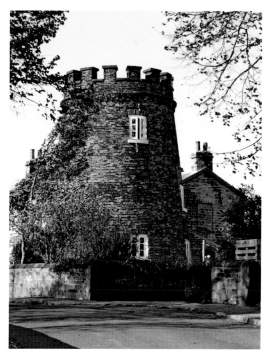

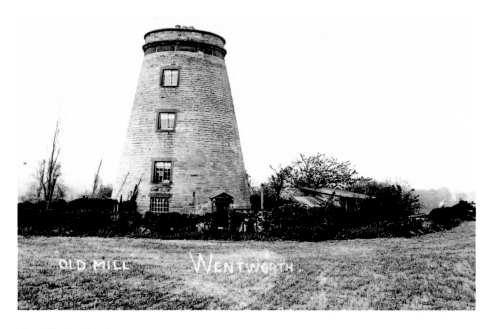

### The Windmill at Barrow

This windmill along Mill Lane to the west of Wentworth, now a private residence, was built in 1793 at a cost of £382 9s 1½d. Beside the stone-built mill a house was built for the miller and his family. Between 1828 and 1831 a steam-powered corn mill was erected beside the windmill and by 1835 the windmill was no longer being used and had been converted into two cottages. Throughout most of the nineteenth century, one family, the Jacksons, lived at the mill.

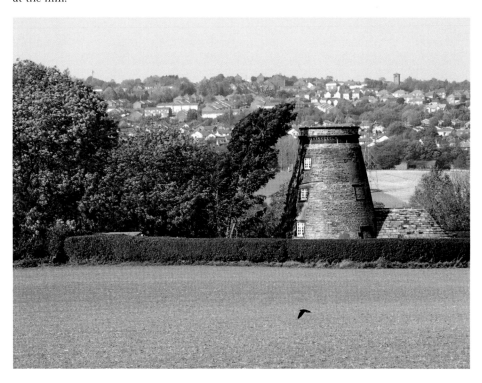

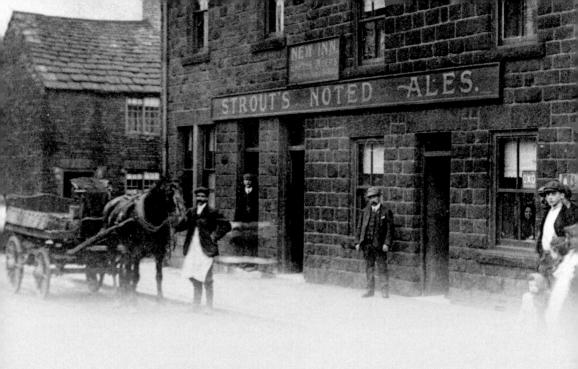

CHAPTER 3

# The Workplace

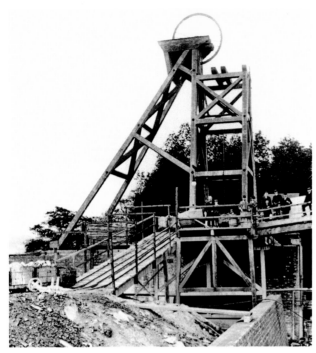

## Sinking Thorpe Pit

The two photographs here show the sinking of Thorpe Pit between 1900 and 1903 by Newton Chambers of Thorncliffe Ironworks. The pit was designed to give easier access to the working faces at their existing collieries at Smithy Wood and Barley Hall. A second, ventilation, shaft was sunk in 1915. The pit closed in 1972. It was used as the setting for the Disney film *Littlest Horse Thieves* and the television adaptation of Barry Hines' *The Price of Coal*.

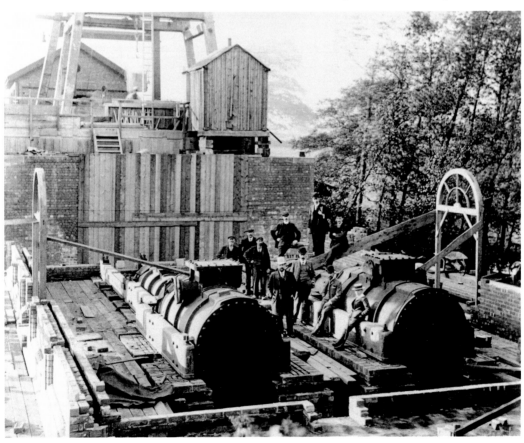

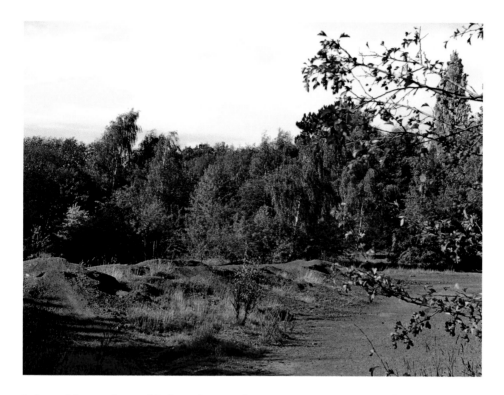

## Informal Recreation and Informal Extraction

The photograph shows the site of Thorpe Pit today. The only evidence that mining ever took place here are the low mounds of shale that were removed as the shafts were sunk. Today the site has regenerated as scrub woodland and is used for informal recreation such as dog walking. The photograph below shows local miners digging for coal for their domestic fires in Hesley Wood during the General Strike of 1926 when Thorpe Pit was closed.

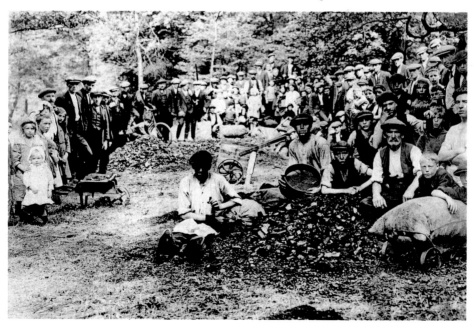

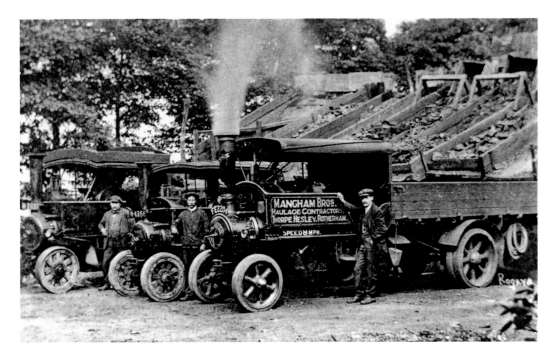

## Scholes Colliery

The early photograph shows Mangham's steam-powered coal lorries being loaded at Scholes Colliery. One of the main markets for Scholes Colliery coal was Rotherham power station. All that remains of the colliery today are two low spoil heaps (called 'muck stacks' locally) covered by scrub woodland.

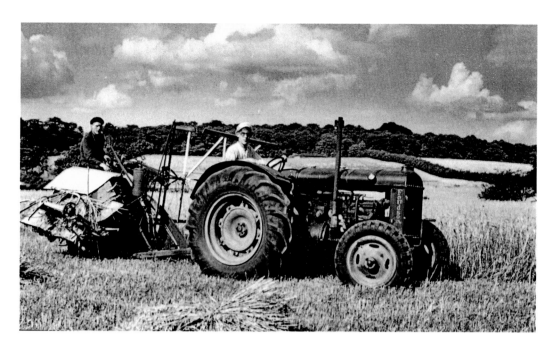

## Down on the Farm

The early photograph shows the binding of oats about 1950 in a field by the sheepwash between Thorpe Hesley and Wentworth. Graham Waller is driving the tractor (a Fordson Standard) and Don Watson works the binder. The rhythm of the seasons continues on local farms as the modern photograph shows, with grass being cut for hay or silage in 2011 in a field beside Upper Wortley Road with Keppel's Column in the distance.

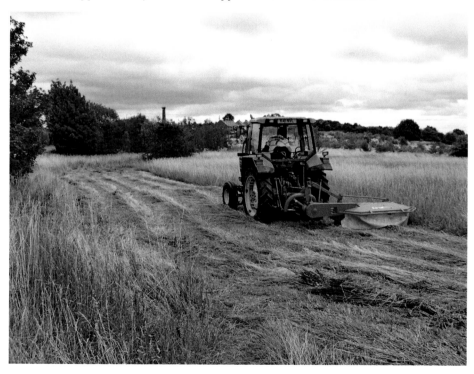

71

72

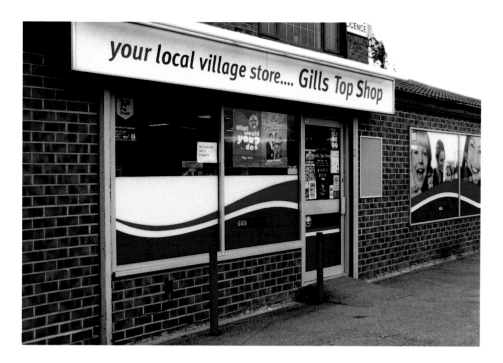

## Change in Store

The page of advertisements shown on the previous page appeared in the *Thorpe Hesley and Scholes Parish Magazine* in 1975. It has been all change in the last thirty-five years or so. But Hamilton's butcher's shop on Upper Wortley Road still functions now as a general store, Gill's Top Shop, and the village has a hairdresser's on Brook Hill run by Yvonne and Jane where massage, manicure and pedicure have replaced Wella permanent waving.

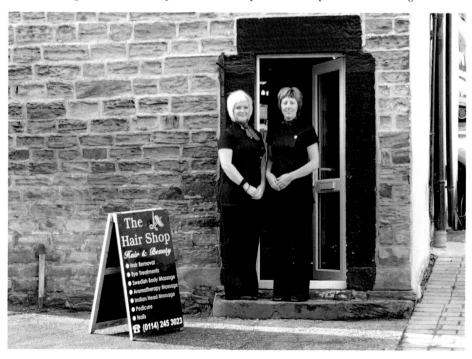

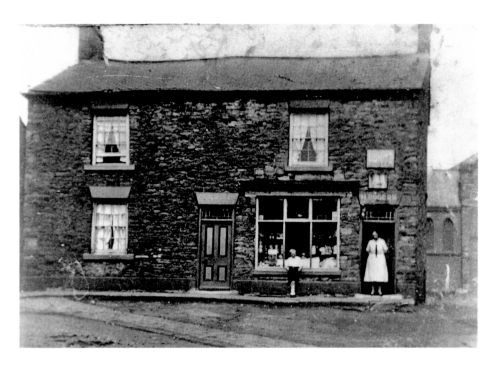

## Picture This...

The old image shows Rogers' stores at the junction of Thorpe Street and Wentworth Road in Thorpe Hesley. From the 1930s it was run by Harrison Rogers and his son, John Rogers, and was still in business until the 1980s. It was a grocer's and provision dealer's which also sold hardware, china, drapery and furniture according to an advertisement of 1938. The shop is now Wychwood Picture Framing.

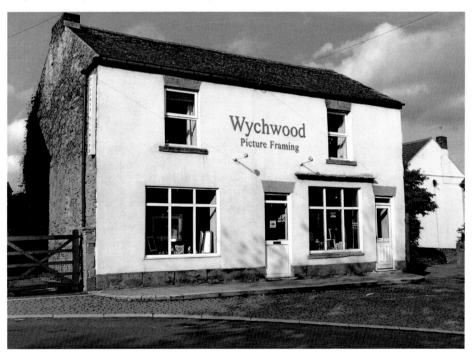

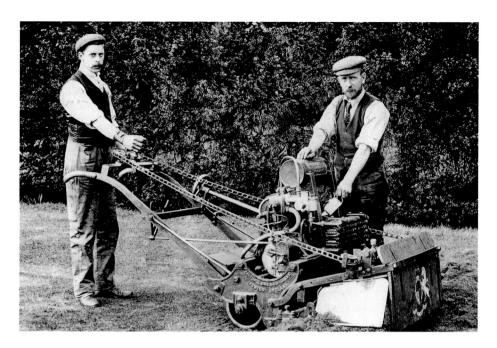

## Gardeners

The early photograph shows a petrol-driven lawnmower operated by Walter Chapman (left) and a colleague in the gardens at Wentworth Woodhouse. Chapman had lost his right arm in an accident when he was a boy but became a valuable member of the gardening team. The modern photograph shows that, although now part of the Garden Centre rather than belonging to the big house, the gardens still need to be kept spick and span, and Lloyd Vaines prepares to trim the yew hedges of the maze.

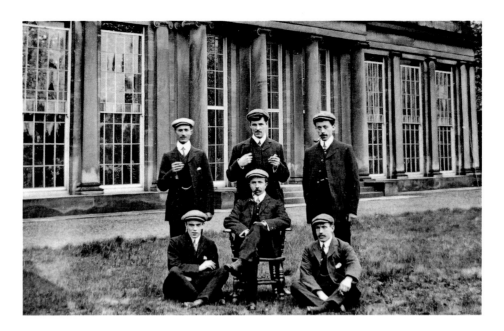

People in Glasshouses...

In the early photograph a group of gardeners, in their Sunday best, pose outside the Camellia House at Wentworth Woodhouse. The exact date of its building is not known but in 1748 a visitor noted that it was very spacious. Glasshouses are still important features in the former grounds of the big house for in the Garden Centre complex there is a specialist firm that sells and erects conservatories.

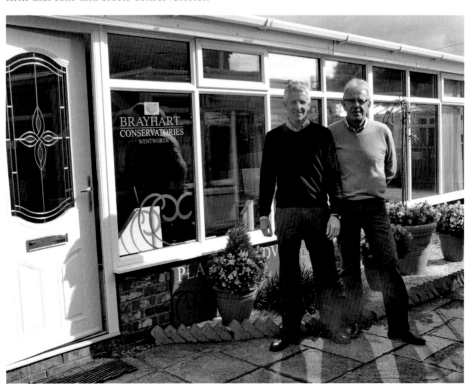

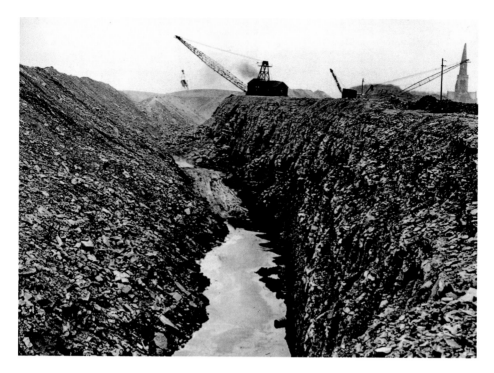

## Turning Wentworth Upside Down

The early photograph, taken in the 1940s, shows opencast mining for coal on the Wentworth Woodhouse estate. It began in 1943 and went on until the early 1950s. Mining even took place in the gardens almost up to the mansion. To many contemporary observers this was a personal vendetta by Emanuel Shinwell, the Minister of Fuel and Power, against Earl Fitzwilliam, a representative of the old order. Thankfully today, as the modern photograph shows, there is little sign of past upheaval.

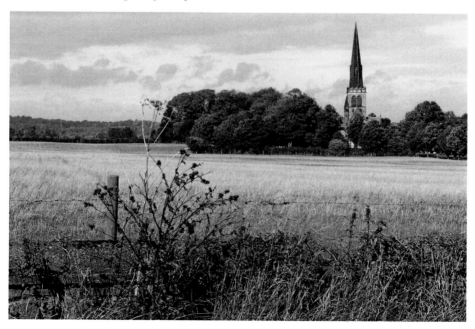

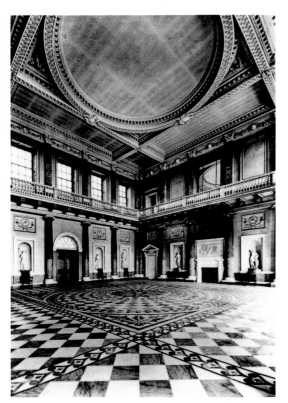

## The Marble Saloon, Wentworth Woodhouse

The photograph above shows the main room at Wentworth Woodhouse, the marble saloon. It is 60 feet square and 40 feet high. The 'marble' Ionic columns are in fact not marble but scagliola, which is a mixture of cement and colouring made to look like marble. This was the room where the marquises of Rockingham and the earls Fitzwilliam hosted grand receptions, balls, christenings, weddings, coming of age and Christmas parties. For example, a local diarist was present (via the servants' quarters) at a grand ball in 1834 at which there were 1,400 guests and the marble saloon was lit by 5,000 oil lamps. In more recent times, as can be seen below, it housed a badminton court (with the marble floor protected by floor boards) for students of Lady Mabel College and was the main examinations room for students of Sheffield City Polytechnic.

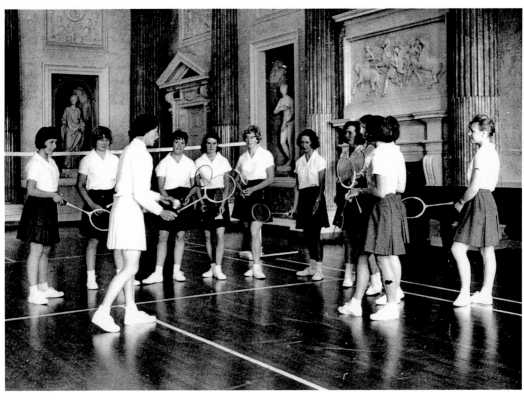

# CHAPTER 4

# People

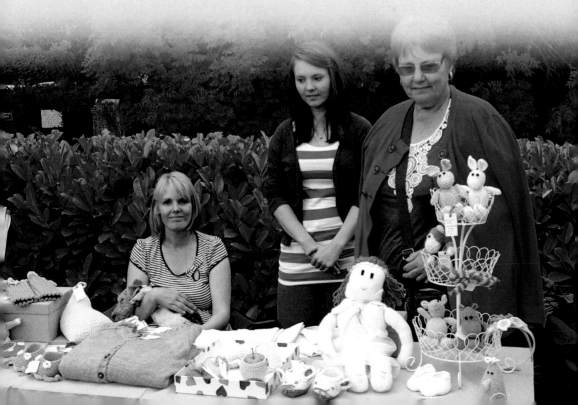

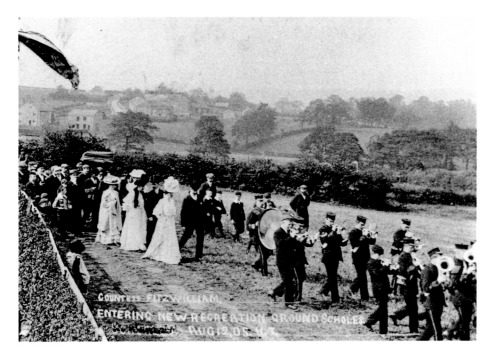

## Celebrations at the Recreation Ground, Scholes

The early photograph shows the procession at the opening of Scholes Recreation Ground in August 1905 by Countess Fitzwilliam. She wore a dress 'in heliotrope trimmed with satin' and a hat decorated with 'large ostrich feathers and chiffon'. The Recreation Ground is now the headquarters of Scholes Cricket Club. The modern photograph shows Chapeltown Silver Prize Band playing and parading through Scholes village as part of the centenary celebrations of the opening of the Recreation Ground.

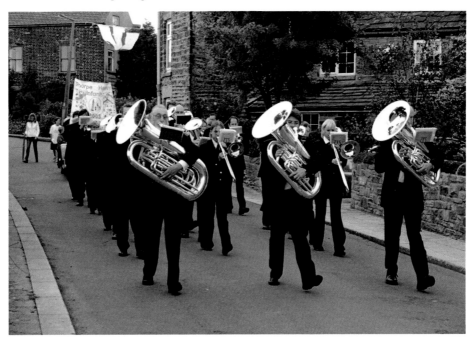

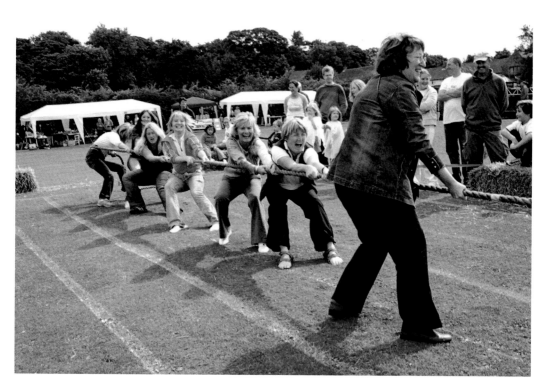

### Exertions at the Recreation Ground, Scholes

The photograph above shows the tug-of-war, one of the many sports and recreations that took place in 2005 at the Recreation Ground to mark the centenary of its opening. The photograph below shows a display by Wild Spirit Allstars cheerleaders at Scholes village fête at the Recreation Ground in July 2011. Among other attractions that day were police dog demonstrations, Beat the Goalie, a coconut shy and vintage cars.

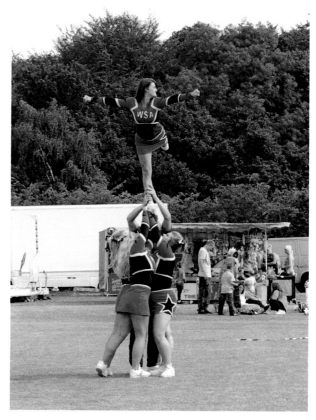

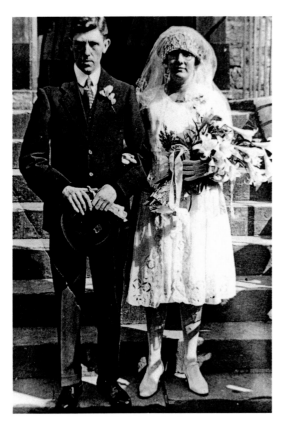

Village Weddings

The two photographs shown here portray two happy couples on their wedding day last century. Above are Edward Ivan Law of Scholes and Lillian Constance Chesman of Thorpe Hesley at Hope Methodist chapel in September 1929. Ivan was a metallurgist for the English Steel Corporation. Both Ivan and Connie were lifelong Methodists and workers at Hope Chapel in Brook Hill, Thorpe Hesley. Below are Clifford Bennett and Winifred Earnshaw on their wedding day on 31 January 1942 at Thorpe Hesley parish church. It was a very snowy day. The service was conducted by the Revd Sydney Edgar Tuffs. At the age of fourteen, Winnie went into service at Thorpe vicarage for the Revd Wilfred Cleghorn and his family.

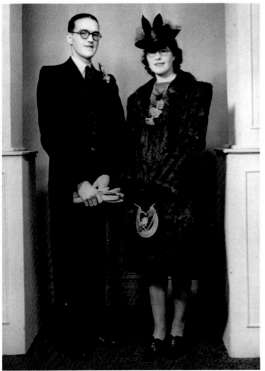

## More Village Weddings

The wedding shown above is that of John Portman and Joan Mary Bennett that took place on 9 December 1967 at Thorpe Hesley Holy Trinity parish church. Joan is the daughter of Clifford and Winnie Bennett, whose marriage is shown on the previous page. John and Joan are both lifelong members of the church. Also shown here is the wedding of John and Joan's daughter, Helen Portman, who married Paul Brookes at Holy Trinity church on 7 April 2001.

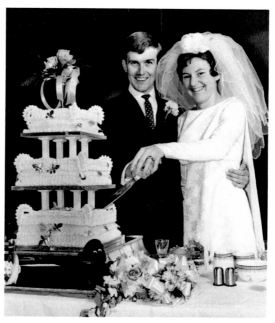

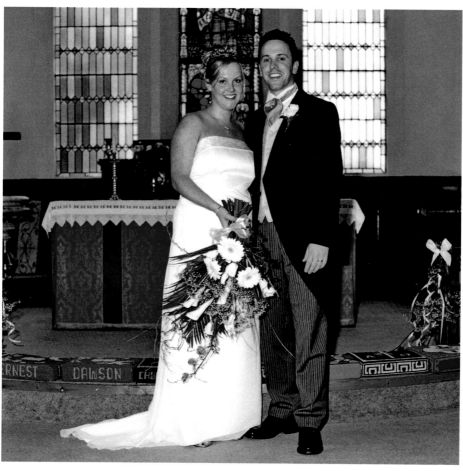

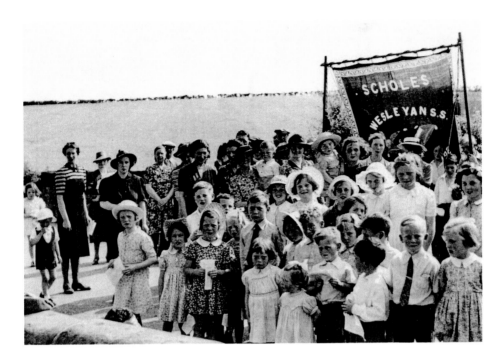

### Outdoor Worship at Scholes

The early photograph shows a Whit parade in Scholes village in 1942. The banner says Scholes Wesleyan Sunday School. The chapel is now closed. The parade was led by Silverwood Prize Band which was originally formed by miners at Silverwood Colliery near Thrybergh in 1909. The more recent photograph shows an outdoor service held on 5 September 2010 at the Scholes Recreation Ground led by the vicar, the Revd Jan Hardy.

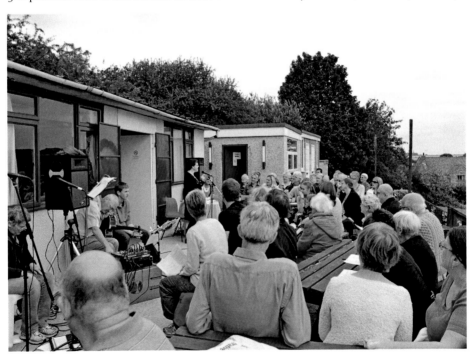

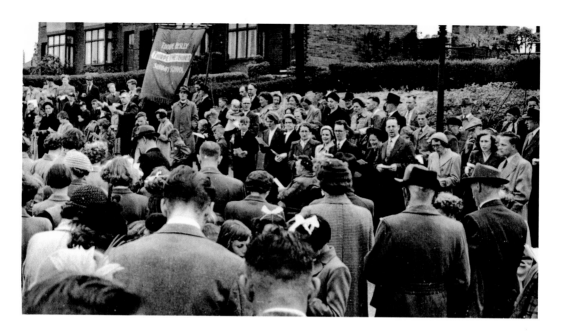

## Outdoor Witness at Thorpe

Above is the traditional Whit Sing in which members of the local church and chapel congregations toured the local area at Whitsuntide lustily singing hymns. This one is on Brook Hill in Thorpe Hesley in the mid-1950s. The singing is being conducted by Lewis Waller. The recent photograph is taken on Palm Sunday in 2010. Members of Holy Trinity church and Sunday School parade with a donkey down Brook Hill to commemorate Jesus' triumphal entry into Jerusalem on a donkey.

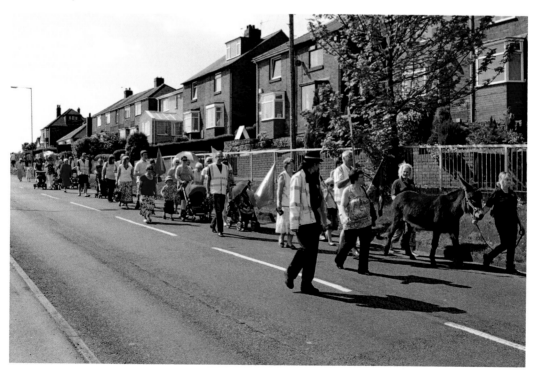

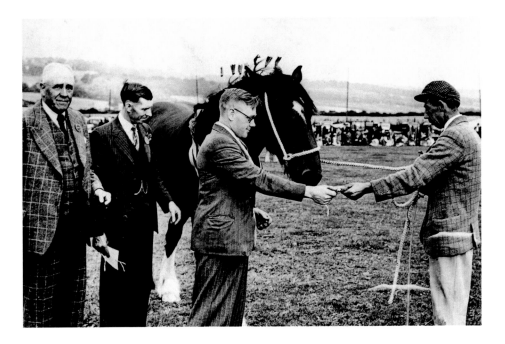

## Top Horses

Horses are always at the centre of village shows. Above is a prize winner at Thorpe Hesley Agricultural and Horticultural Show in 1945. The award is being presented by Frank Senior attended by Frank Bettney (left) and Arthur Brown of Kirkstead Abbey Grange Farm (chairman). Below (left to right) in fancy dress are Maisie Birmingham, Jordan Robinson and Dawn Robinson and their beautiful steeds giving rides to Isabel Shenton and Lily Shenton at Thorpe Hesley and Scholes Village Show in 2011.

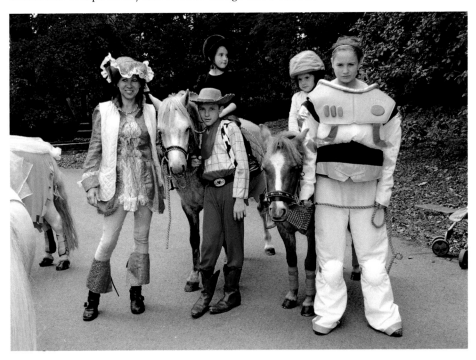

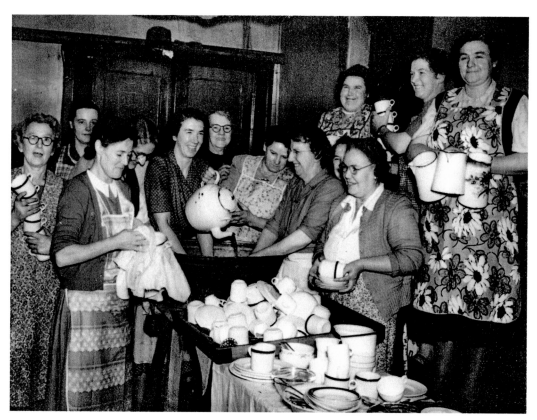

## Washing Up Time

The photograph taken in the late 1940s shows ladies washing up after serving tea to the judges and stewards at Thorpe Hesley Agricultural Show. There were obviously lots of judges and stewards and it must have been very thirsty work. The modern photograph shows a busy kitchen scene at the Trinity Community Centre during the Thorpe Hesley and Scholes Village Show in September 2011. The Community Centre hosted craft, cookery, vegetable, fruit and flower competitions. Outside many stalls offered their wares and one of the main attractions was an enthusiastic display of Zumba dancing!

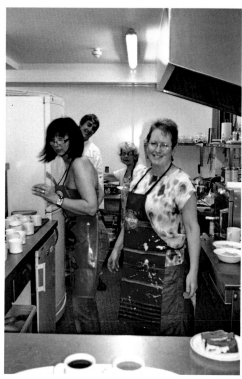

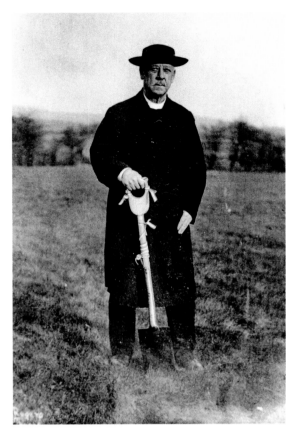

Energetic Vicars, Then and Now
Above is the Revd Robert Trim
Charles Slade, Vicar of Thorpe Hesley
from 1881 to 1921, opening allotments
on the site of the present Thorpe
Hesley Primary School during the First
World War. Eagerly awaited every
year was his Christmas visit to local
schools where he gave every scholar a
shiny new penny. Below is the present
vicar, the Revd Jan Hardy, during her
parachute jump from 15,000 feet in
2011 to raise money for the parish
church stonework appeal.

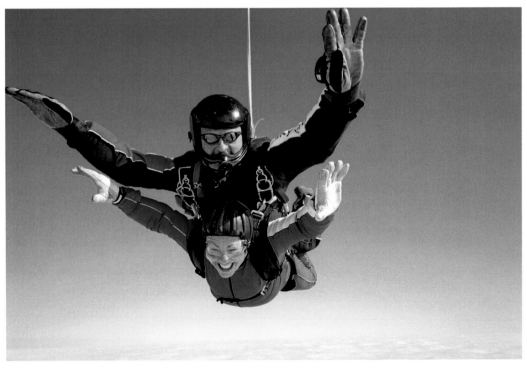

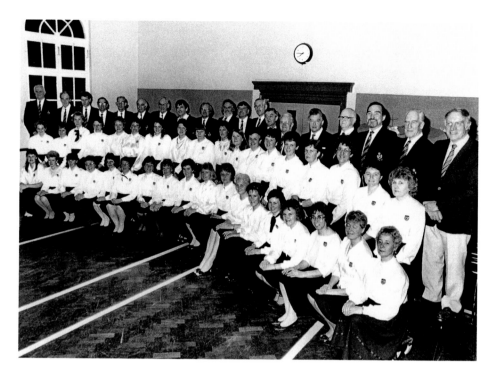

## Singing Together

Above is the Thorpe Hesley Village Choir shown here in the year of its foundation, 1986. It was formed for one Christmas performance by local head teacher Brian Copley (on the extreme right of the back row). The choir is still going strong as you can see below. It is a mixed choir of about forty members. The choir's repertoire includes traditional songs, selections from musicals and music by classical and modern composers. It regularly performs at festivals, fundraising events, Christmas celebrations and weddings.

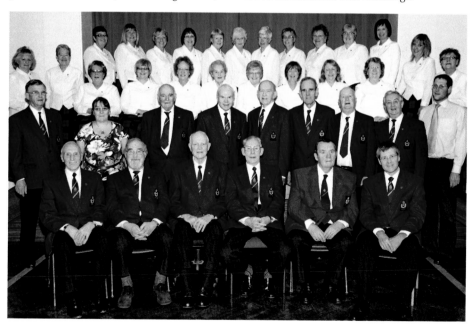

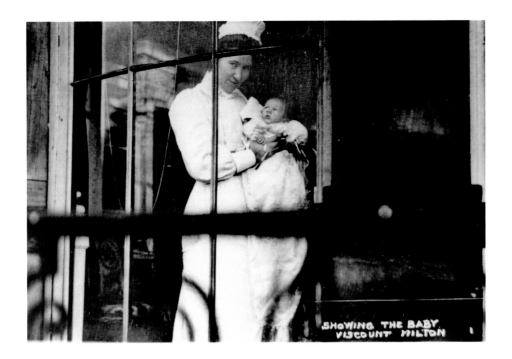

## Showing the Baby

Above head nurse 'Nannie' Rae displays to the photographer Peter, Viscount Milton, the future 8th Earl Fitzwilliam, on the day of his christening, 11 February 1911. The christening was almost like a coronation because Peter had been preceded by four sisters and it was feared that the earldom would go to another branch of the family. There were 7,000 officials guests at the christening. Below, the Revd Richard Buckley holds Amber Nicole Kennedy after her christening in Wentworth parish church in 2011.

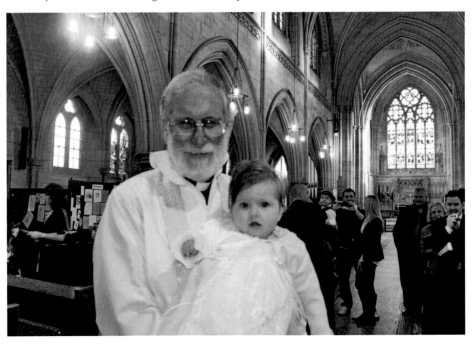

**Barrow School and Pupils**
Wentworth Barrow School was founded by the Hon. Thomas Watson-Wentworth in 1716 'for fifty poor children'. It closed in 1943. The complex of buildings, the entrance of which is shown above, originally included a schoolroom, a house for the schoolmaster and a group of almshouses arranged around a quadrangle. It was enlarged in 1892. The big schoolroom contained a three-tier gallery along the south wall, an open fire in the centre of the north wall (with the head teacher's desk close to it), two blackboards and a harmonium. In the playground the boys played football with anything that would roll, from a potty to a pig's bladder. The photograph below shows the boys in Standards I and II at the school in 1905.

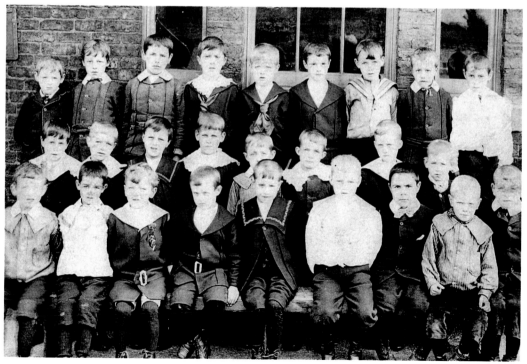

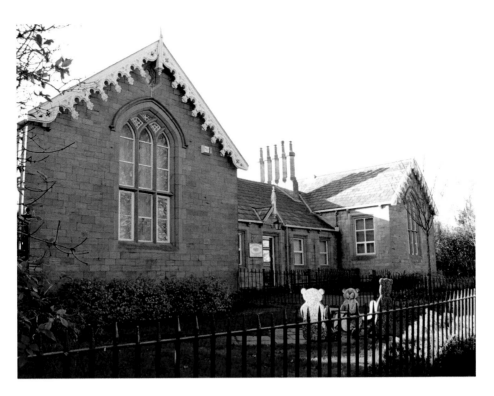

## Wentworth School

Wentworth School, shown above, was opened in 1837 as a mixed infants and girls school. The 5th Earl Fitzwilliam gave the land and contributed to the building costs. He also established the Wentworth Charity which provided clothes and a free education for twenty-five boys and twenty-five girls. In 1841 a report stated that 'this is a real school ... they are instructed, not merely dragged along in the ruts of the old road'. The photograph below shows an infants' class in about 1907.

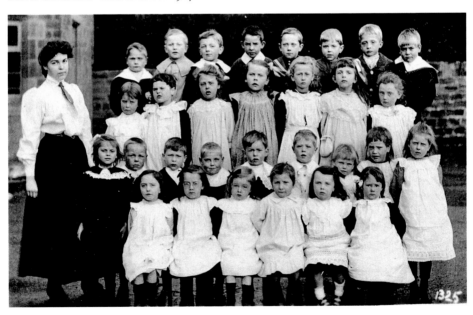

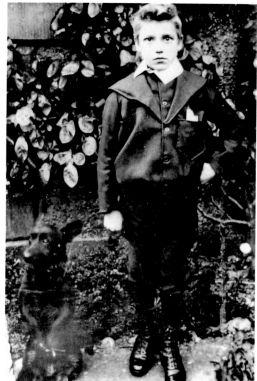

## School Uniforms

Sidney Butterworth can be seen here in 1898, aged ten years when he was a pupil at Wentworth Barrow School for Boys. On the left in the shadow is his pet dog sitting up begging; quite a feat to catch that on camera! Below is Ruby Branson aged six years, a pupil at Thorpe Hesley Infants School in 2011, holding her book bag. Ruby's favourite subjects are art, number work and reading. She is also a school councillor!

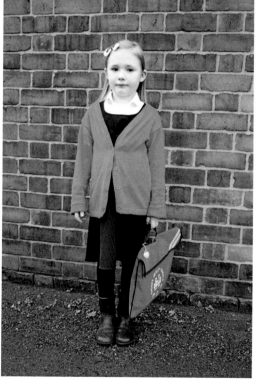

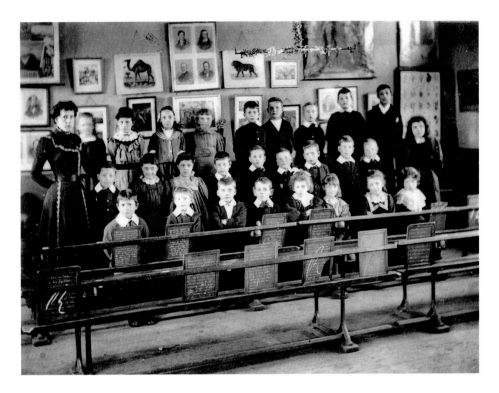

## School Groups

The photograph above shows a well-scrubbed and beautifully turned-out class at the Wesleyan Day School, Thorpe Street, Thorpe Hesley, over a hundred years ago. A close inspection shows gas lighting, neat handwriting on the slates and an array of pictures on the wall including a camel and a lion, presumably visual aids for 'object lessons'. The photograph below shows Standard V at Thorpe Hesley Council School in 1912. The girl in the middle of the front row proudly holds an attendance shield.

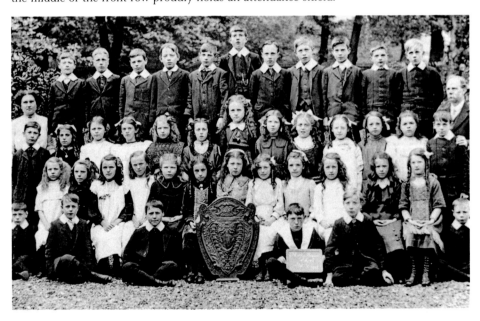

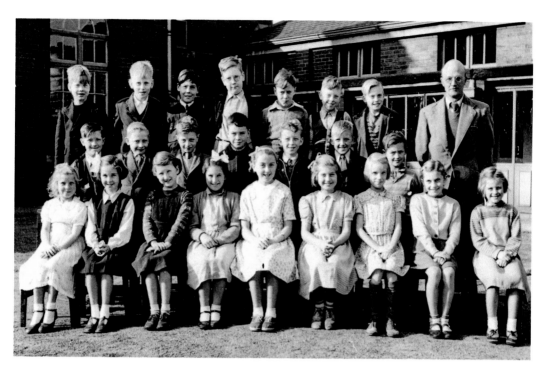

## Thorpe Hesley County Primary School

The photograph above shows a class at the Thorpe Hesley County Primary School in the 1950s. The class teacher is Mr Hopkinson. The school opened in 1929 in succession to the Wesleyan Day School and the National School. The photograph below shows a class at the same school in 1985 with the head teacher Mr Brian Copley on the right at the back.

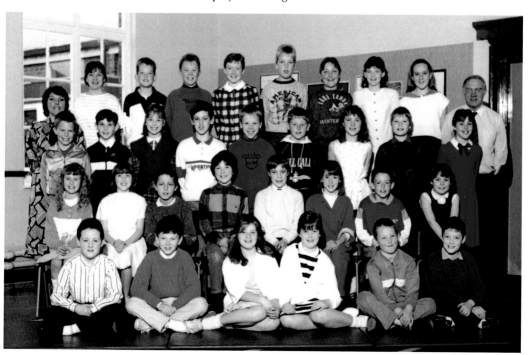

# Acknowledgements

The authors would like to thank the following for the donation or loan of photographs and/or accompanying information: Marian Barraclough, Winnie Bennett, Pauline and Michael Bentley, Alan Boulton, Richard Buckley, Elma Casson, Chapeltown & High Green Archive, Chris and Pete Chapman, Robert Chesman, Stephen Clapham, *Country Life* Magazine, Sue Dixon, Bill Dunigan, June Falding, Chris Gillam, Jan Hardy, Elvy Ibbotson, Marjorie Law, Ken Peet, Joan and John Portman, Harold Price, Rotherham Local Studies Library, Chris Sharp ('Old Barnsley', Barnsley Market), Sheffield Industrial Museums Trust, Dontaia Shelmerdine, Joan Steel, Pat Swift, Thundercliffe Grange residents, Jim Varney (courtesy of WREN), Graham Waller, Anne and Howard Willey, Chris Woods, Eve and Colin Woods and Ena Womersley.

We apologise if we have inadvertently omitted the name of any contributor.

The old image on the front cover shows members of Thorpe Street Methodist chapel at the crowning of the Sunday School Queen ceremony in 1947.

Two 'incomers' who have only lived in Thorpe Hesley for twenty-seven years but are still enthusiastic about the local scene. Guess who?!